BYRON BIRDSALL'S
A L A S K A

ALASKA
NORTHWEST
BOOKS®

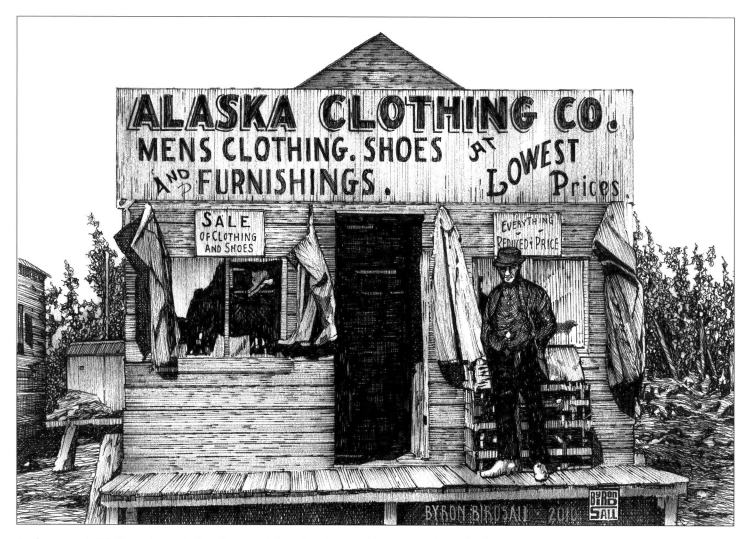

Anchorage—1909: Several years before the great influx of settlers would permanently put Anchorage on the map, the first pioneers set up trading posts in the wild.

CONTENTS

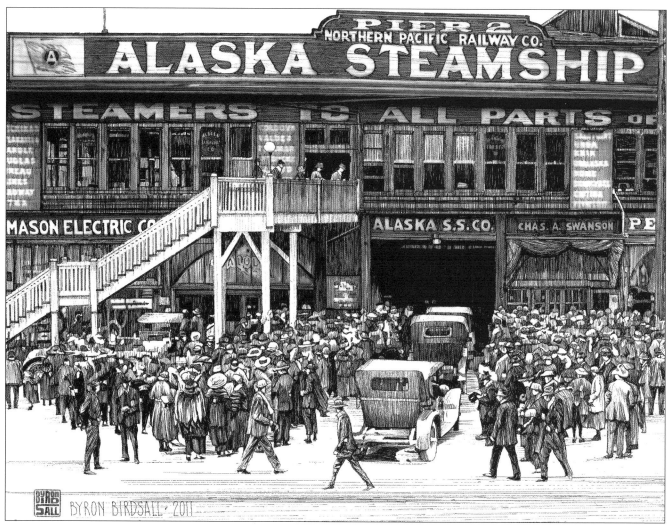

North to the Future, Alaska Steamship Co. Pier 2, Seattle—c. 1927: The Merchant Marine Act of 1920 forced out the Canadian shipping competition. The eighteen ships of the Alaska Steamship Company held a virtual monopoly.

FOREWORD

No painting technique is safe from Byron Birdsall. Having made his bones in watercolor with his first solo show in 1967, by 1981 he had moved into oils, and as if that weren't enough, by 1987 Byron's homage to Russian icons stepped out in all their gilded moodiness, transporting the viewer straight back to the days of the Russian czars and the Russian Orthodox Church. I remember a painting that I swear was channeling Rasputin.

One constant throughout Byron's work has been color, from the delicate washes of his early watercolors to the bolder hues of his oils to the glitter of gold in his iconography. In this collection, just to keep us on our toes, he is switching to pen and ink sketches in black and white. He writes

. . . in 2005 Billie and I were
on the St. Charles Bridge in Prague, and I saw a chap
sketching away in black and white. I watched him for
awhile, and then bought one of his sketches.
I was fascinated and decided to try it for myself.

In his artist's statement Byron says that he is marrying his new-found fascination with pen and ink with his lifelong love of history, which I give you fair warning will rapidly become your fascination, too. Page through this volume once and you'll appreciate his eye for choosing just the right historical photographs to inspire his evocation of times gone by. Page through it again and you'll notice how the styles of the automobiles act as milestones on this journey. A third time and you find your attention drawn specifically to what changes over the years and, more importantly, what doesn't.

I love "City Hall, Anchorage, c. 1947" (p. 28) for the old bus, the older buildings, the styles of dress, including the uniforms that make you remember that we had just been at war, and that Alaska had been a vital part of the Lend-Lease route that ferried airplanes and war materiel to Russia through Siberia. But looming always in the background are the Chugach Mountains, Tikishla and Near Point and Wolverine. You can't see Flattop behind City Hall, but you know it's there, and you know that when that particular City Hall building is gone, Flattop will still be there because you hiked it last solstice. If that doesn't qualify "City Hall, Anchorage, c. 1947" as a time machine I don't know what does.

Byron says that most of his inspiration for these sketches comes from the online photography archives of the University of Alaska and the Anchorage Museum at Rasmuson Center. But a photograph only freezes a

moment in time, it doesn't interpret it. In his sketches Byron's pen thaws these moments into a liquid reflection, a ripple of light and shadow connecting present to past.

My favorite in this collection is "Beautiful Downtown Ketchikan, c. 1935." (p. 66), which exceeds its brief of historical nostalgia to stray into social and cultural commentary. Here we have a working dock in a panhandle port. At bottom right is a fisherman wearing one of those old Greek-style fisherman's caps. Next to him looms a totem pole topped with a very stern-looking Raven. Almost directly across the street and dwarfed by the totem pole is a light pole, strung with many electric lines crisscrossing overhead. At the far end of the dock a steamer is moored, smokestack emitting a waft of smoke. Maybe it just got there, maybe it's firing up the boilers prior to departure, we don't know.

But the dominant figure is the totem pole. It may have been debased by being set up as a come-on for a gift shop, but it hasn't lost one shred of its dignity. It was there first, and even if it was traditionally meant to dissolve over time beneath the onslaught of wind and weather, you get the feeling that in spirit at least it will always be there, the Raven from its lofty perch louring down on everything—and everyone—that comes after.

Or that's what I see. Byron's genius is that you may see something completely different.

—Dana Stabenow, 2015

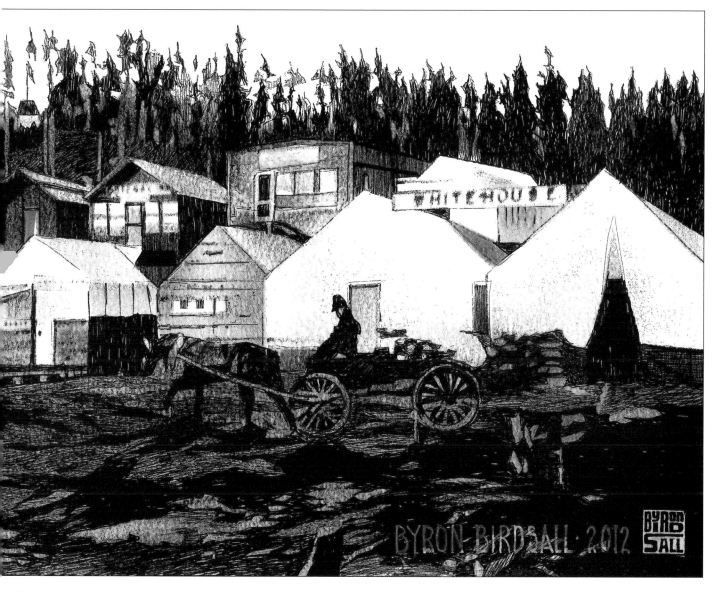

Ship Creek—1915: When the railroad headquarters moved from Seward to Anchorage, a tent city quickly sprung up around it.

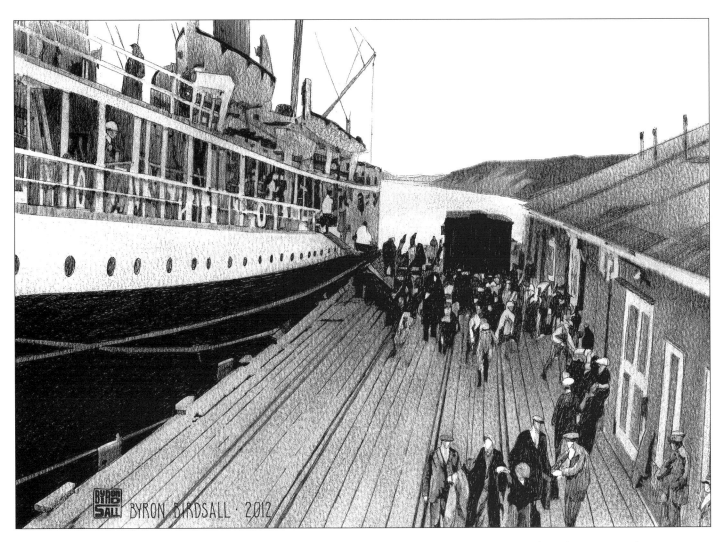

Round trippers on the S.S. *Alameda*, Port of Anchorage—14 July 1923: The iron-hulled S.S. *Alameda* ferried tourists, settlers, and cargo from Seattle to Alaska for over twenty years. She would later be scrapped after catching fire at her Seattle pier in 1931.

ARTIST'S STATEMENT

I have wanted to be a full-time artist since I was eight years old, when my father handed me a sketch pad and pencil, the better to keep me quiet in church. It worked. I drew and painted every spare moment since my eighth year, even when I should have been doing other things.

And then, thirty-two years later, my dream was realized, and I have been painting and making a living at it for the past thirty-four years. Think of it, painting all day and having a roof over my head, with enough left over for groceries.

Such has been my happy lot.

My work has evolved over the years, influenced by extensive travel to Africa, Japan, New Zealand, Europe, and other countries. I work primarily in watercolor, but often turn to oil painting, stone lithography, mosaic, and iconography.

Happy as an artist, I nonetheless had other itches to scratch. I was a history major in college and then taught history in high school for several years. History is a passion for me to this day. I have always strived to go back in time.

I have also admired those who had a special talent for pen and ink.

Then I had a flash!

Why not combine my fascination with history and my interest in pen and ink? And what better subject than the history of Alaska, where I have made my home for forty years. So I tried doing one, and then another, and then another, and I couldn't stop. This modest volume is the result. It is my hope that it captures the special spirit and joy of The Last Frontier that I have called home for many years.

That said, I think my life could be summed up no better than by Pablo Picasso, who once said, "I paint as I breathe. When I'm working I'm resting."

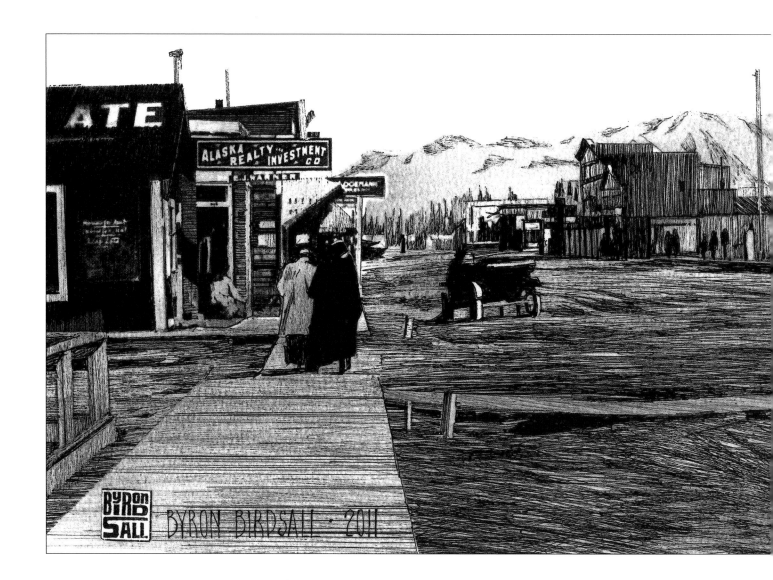

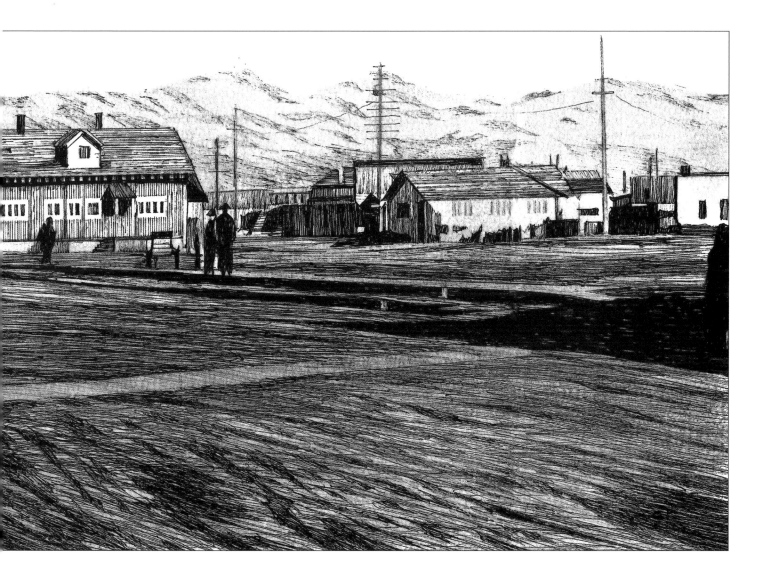

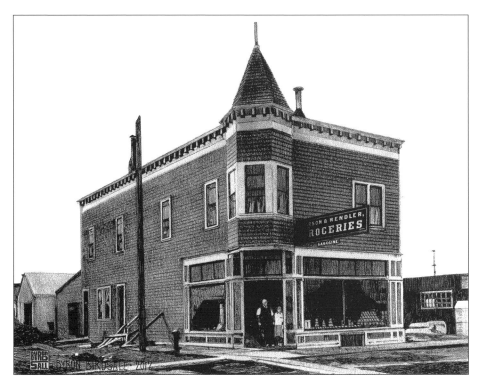

This building, one of the first in Anchorage, survives but has been moved to a different location. I was a friend of that little girl, Myrtle, but only when she was older. —B. B.

⚭ **Fourth Avenue, Anchorage— 1917:** The founders of Anchorage knew their city would grow. The entire town site was mapped out with enough roads and streets to keep settlers busy for decades to come.

◐ **Larson and Wendler Groceries, Fourth Avenue, Anchorage— 1916:** One of the oldest structures in Anchorage, the Wendler Building has been moved several times but now resides next to the city's statue of Balto.

◑ **Anchorage gets its sidewalks, Fourth Avenue—1916:** Not far from the firebreak that would become the Delaney Park Strip, Anchorage laid out its permanent foundations next to its first movie theater, the Empress.

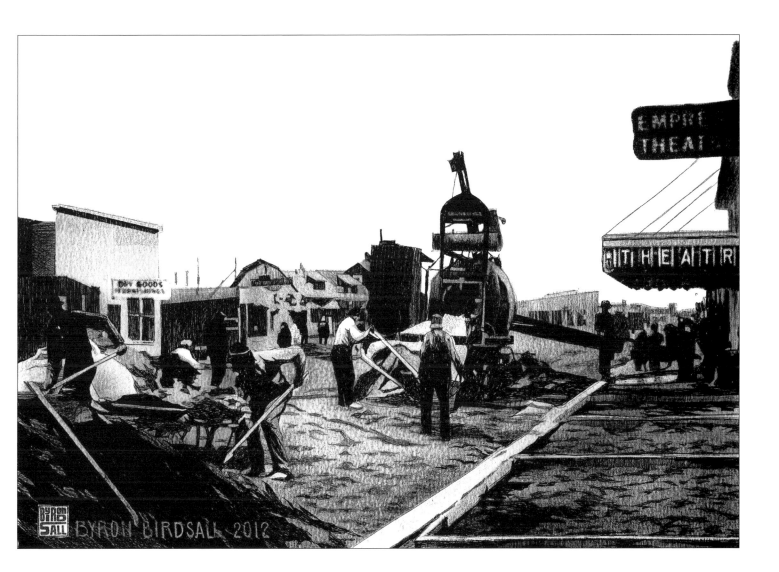

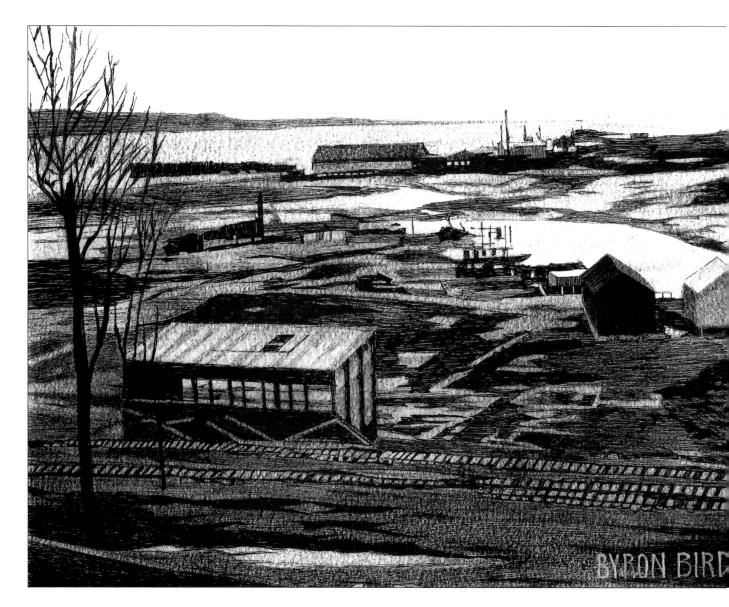

Anchorage Harbor and mouth of Ship Creek— 21 October 1921: Before the Alaska Railroad was completed, ships and steamers were the fledgling city's only lifeline.

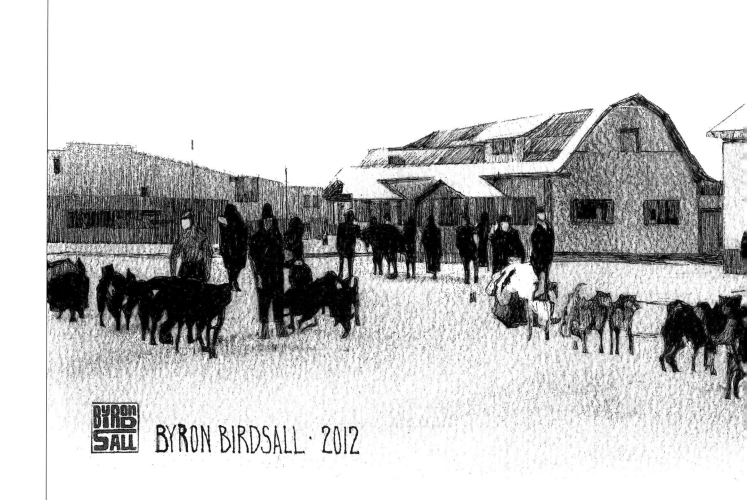

BYRON BIRDSALL · 2012

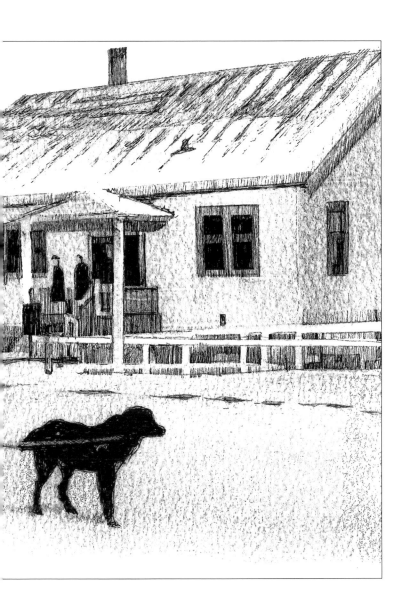

First overland mail leaving Anchorage—18 November 1916: At 10:00 AM with a temperature of twenty-four degrees below zero, $88,000 worth of gold dust and mail pulled out of Anchorage on the first overland mail trip to Seward.

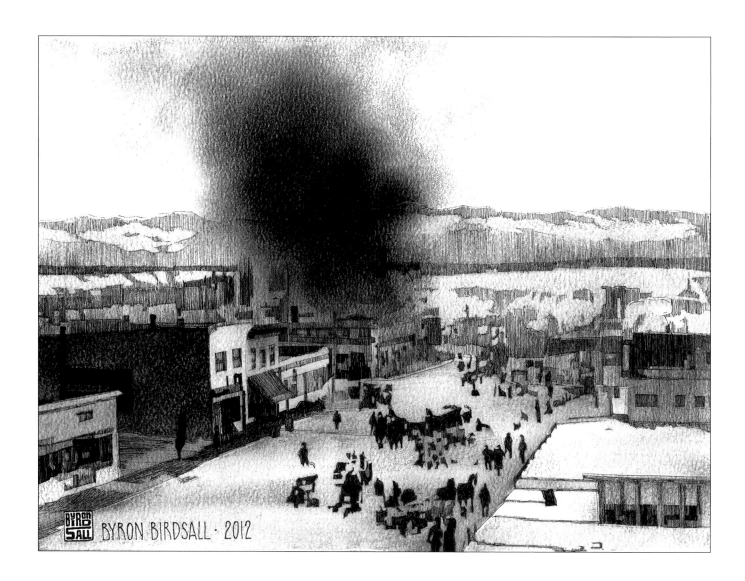

BYRON BIRDSALL · 2012

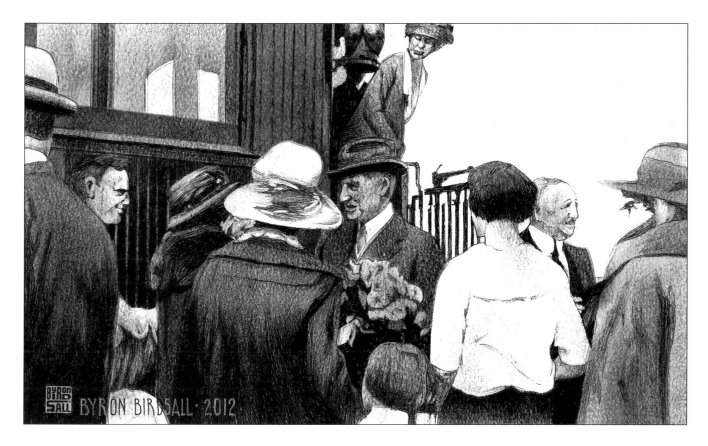

BYRON BIRDSALL · 2012

○ **Anchorage Fire, Fourth Avenue—
7 February 1922:** As the city grew, so did its
needs. Originally unsure if the vehicles of the time
could handle the snow, Anchorage bought its first
fire truck in 1922, an American La-France type 12.

○ **President Harding in Anchorage—17 July
1923:** The first sitting president to visit Alaska,
President Harding greets well-wishers. His trip was
meant to encourage settlers and veterans to move
to the sparsely populated territory.

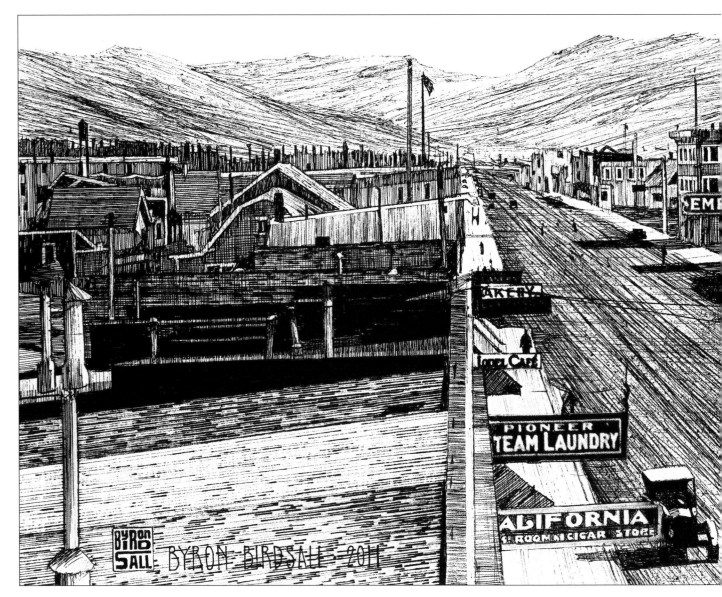

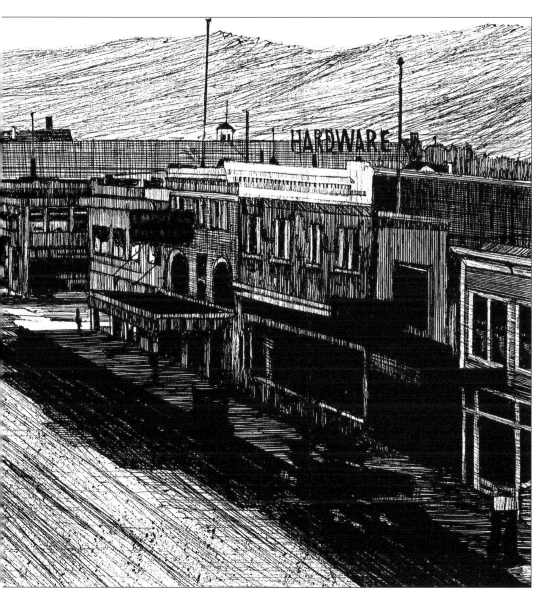

Fourth Avenue, Anchorage—1927:
After finishing the railroad, Anchorage saw a greater influx of material and capital as a center of transportation into and out of the Interior.

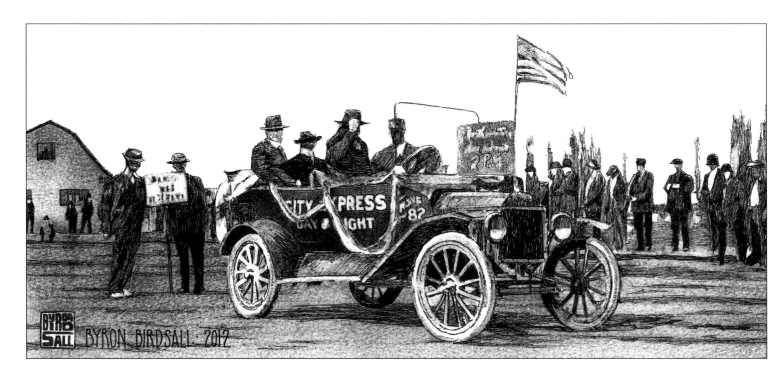

o **Joe Spenard and the City Express Taxi, Anchorage—1916:** Joe Spenard started the city's first taxi service with a 1915 Ford Model T, reputed to be the first automobile in Anchorage.

o **Sophia Loren and Maurice Chevalier in *Breath of Scandal*—1964:** The construction of the Fourth Avenue Theater was interrupted by Word War II, but it was finally finished in 1947. The 960-seat theater was home to first-run movies until 1980.

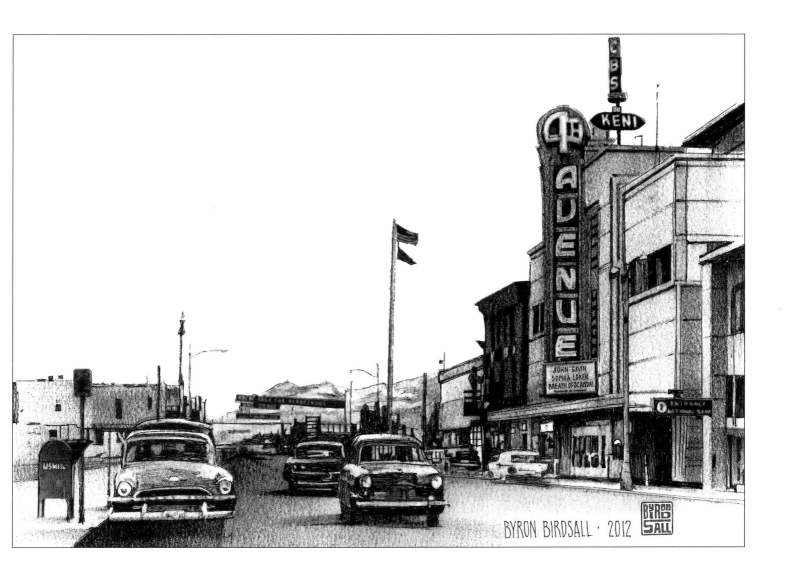

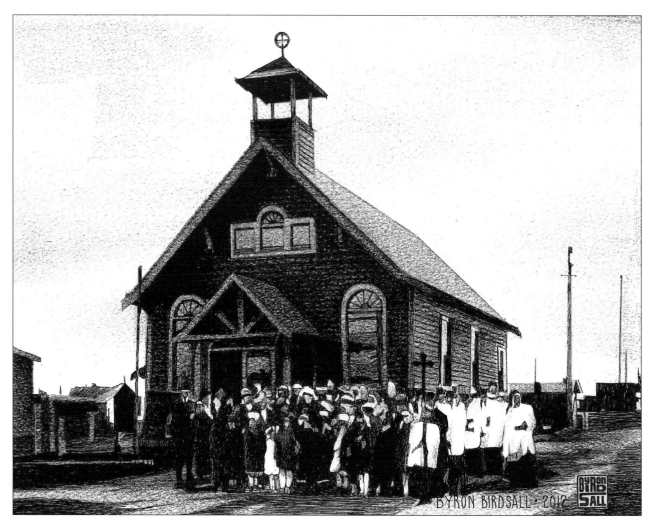

This church still survives in downtown Anchorage in only slightly altered form, and Father Normal Elliott, now in his nineties, still survives and serves the church. —B. B.

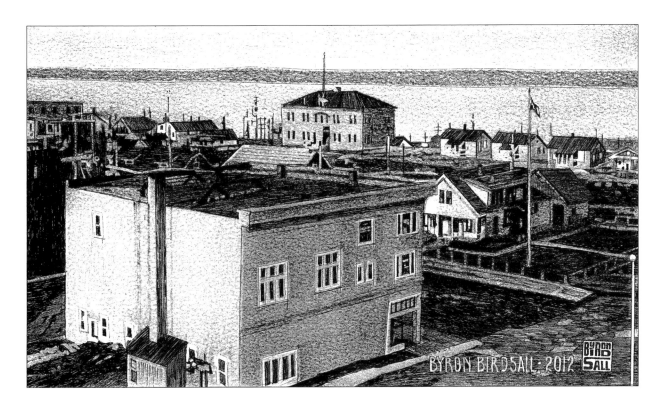

BYRON BIRDSALL·2012

○ **All Saints Episcopal Church—7 May 1922:** Called the "mother-ship church" of Anchorage, All Saint's Parish held services in the Log Social Hall as early as 1915, moving to their new home in 1917.

○ **Downtown Anchorage:** Views of the inlet characterized the most desirable properties in Anchorage.

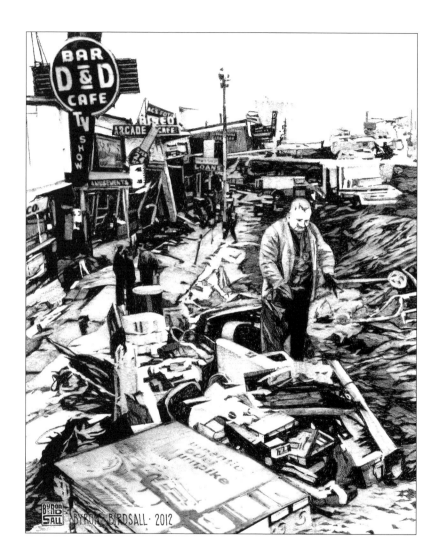

○ **Fourth Avenue, Anchorage—30 March 1964:**
Anchorage's "Where were you?" moment. The
1964 earthquake was the second-strongest
seismic event in recorded history, registering
9.2 on the Richter scale.

○ **Fourth Avenue, Anchorage—27 March 1964:**
The earthquake lasted nearly five minutes,
generating tsunamis across the Pacific. In Kodiak,
areas shifted upward more than thirty feet.

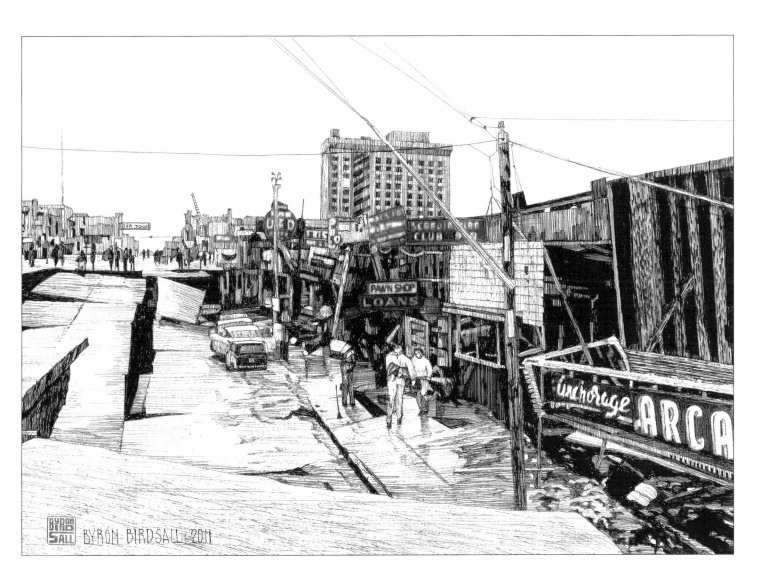

BYRON BIRDSALL·2011

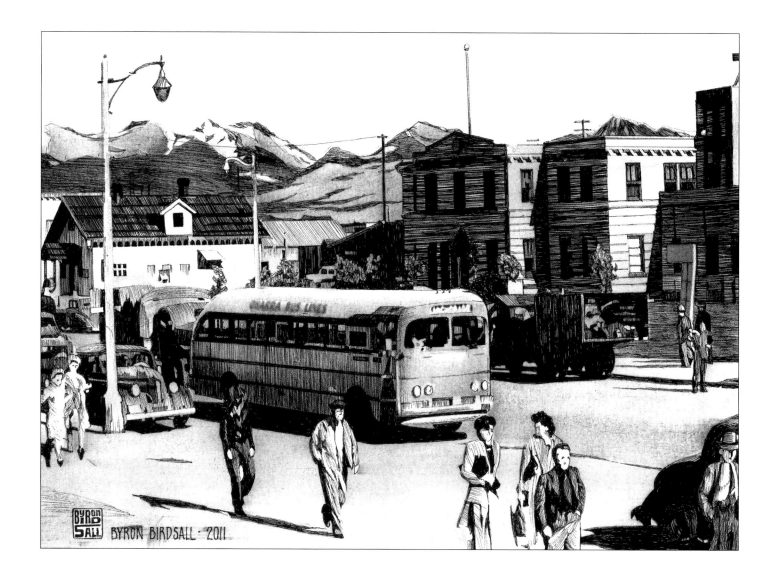

BYRON BIRDSALL · 2011

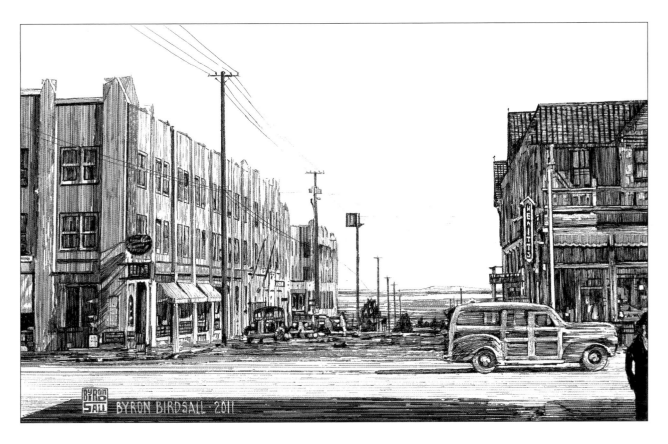

BYRON BIRDSALL · 2011

○ **City Hall, Anchorage—c. 1947:** Built in 1936, Anchorage's second city hall was built with cast concrete, one of the first in Anchorage to be built with the material.

○ **Fourth and E Street, Anchorage—c. 1940:** The 1940s saw the end of Anchorage as a company town, with the building of Elmendorf Air Force Base and Fort Richardson. The city's population would triple through the decade.

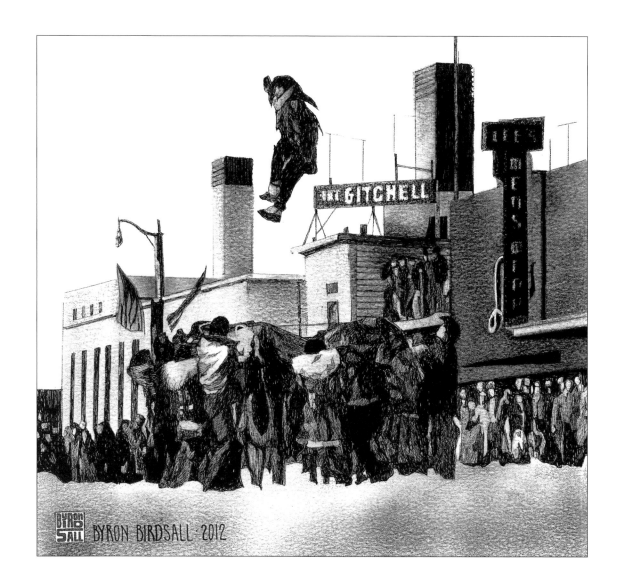

BYRON BIRDSALL 2012

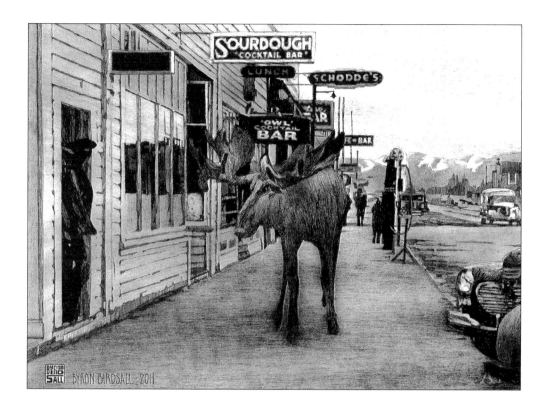

BYRON BIRDSALL : 2011

○ Blanket Toss, Fourth Avenue—February 1950: Typically part of the spring whaling festival, Nalukataq, the blanket toss joined the Fur Rondy celebrations starting in 1950.

○ Seymour on Fourth Avenue: Moose are a common sight in Anchorage, as it is home to more than 1,500. As such, the mascot Seymour was created in 1980 as a goodwill ambassador for the city.

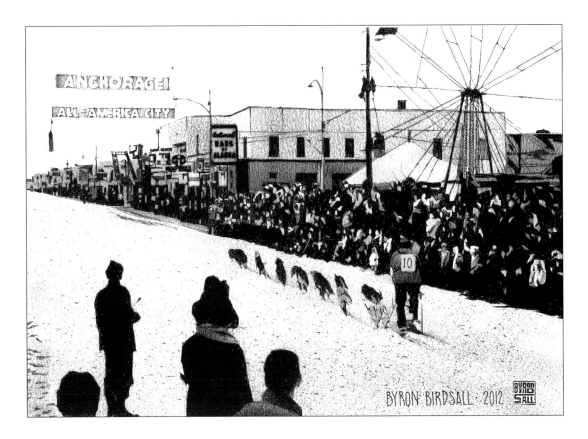

ANCHORAGE!
ALL-AMERICA CITY

BYRON BIRDSALL · 2012

○ **Fur Rondy—c. 1960:** What started in 1935 as a three-day sports tournament has grown to a ten-day celebration of all things Alaska, from the Running of the Reindeer to sled-dog races.

○ **Alyeska—16 February 1961:** Alyeska, the original Aleut name for Alaska, is the largest ski area in the state with over 1,400 acres and seventy-three runs of powder for skiers and snowboarders alike.

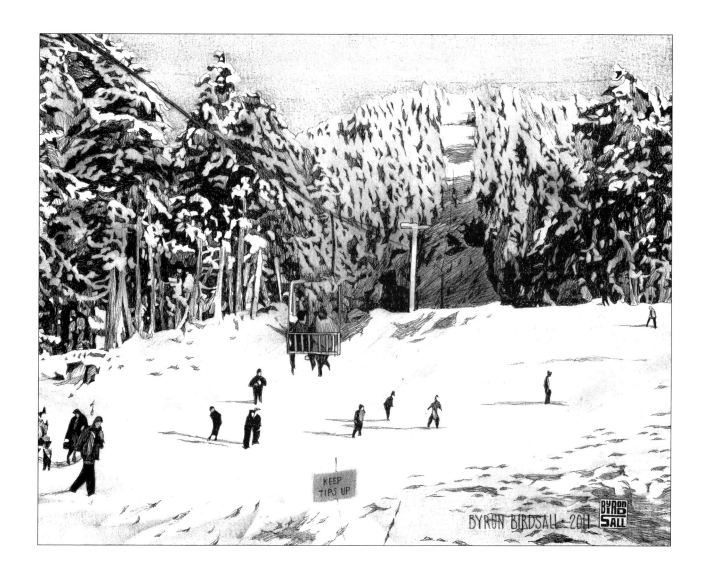

**Beautiful Downtown Wasilla—
1931:** Wasilla began as a jumping-off point for the nearby Knik Mine, but it soon overshadowed the mine when it became the agricultural center of the state.

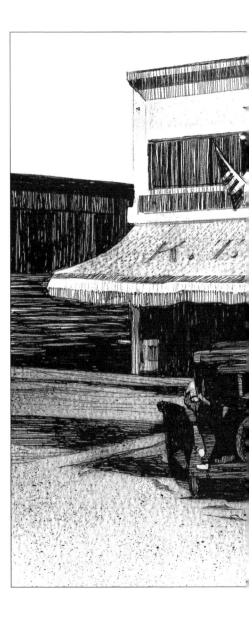

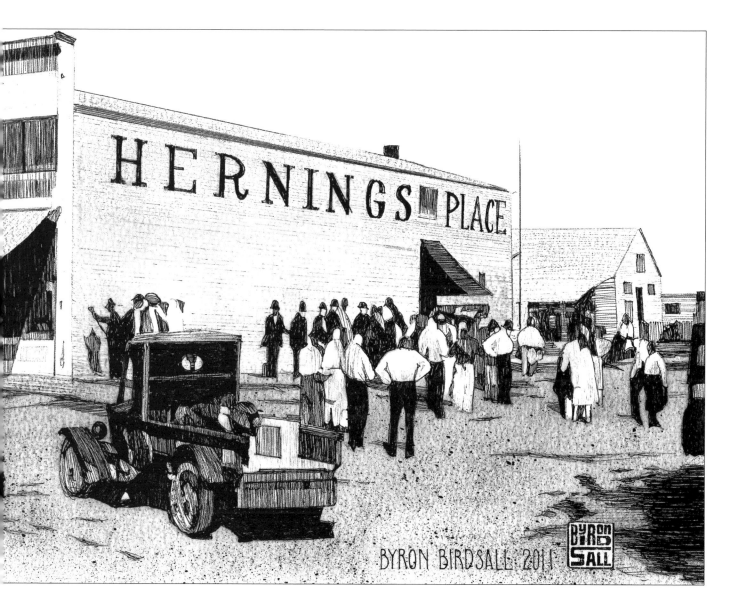

BYRON BIRDSALL 2011

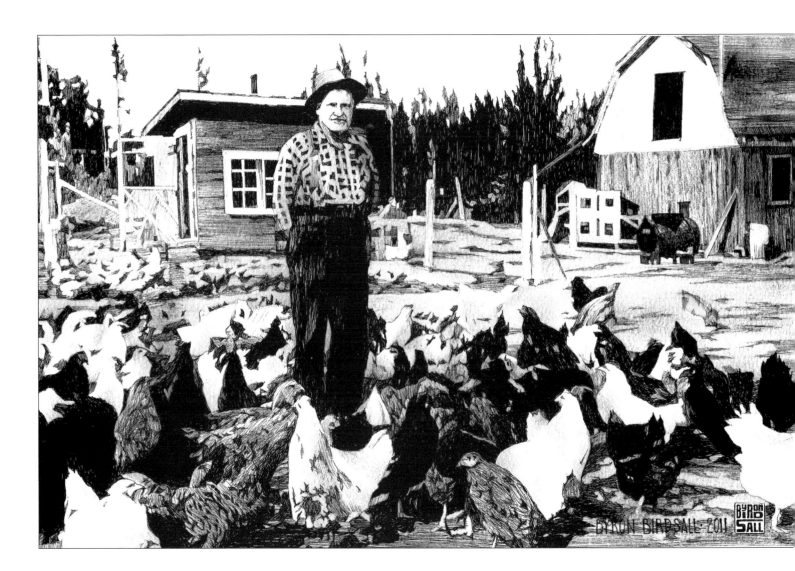

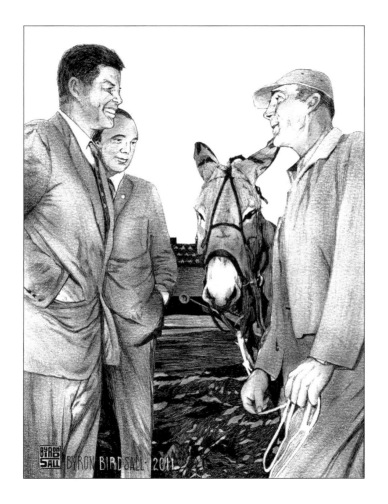

I recognize two of these Democrats but who are those other two? —B. B.

◐◐ **Getting Ready for the State Fair— c. 1933:** The Alaska State Fair has evolved into a week-and-a-half festival. Originally meant to show off the harvest, the fair is home to world record–sized vegetables.

◐ **Four Democrats at the Palmer State Fair— 3 September 1960:** With notable visitors like President Kennedy, the state fair brought and continues to bring together the best of Alaska through art, games, music, and just plain fun.

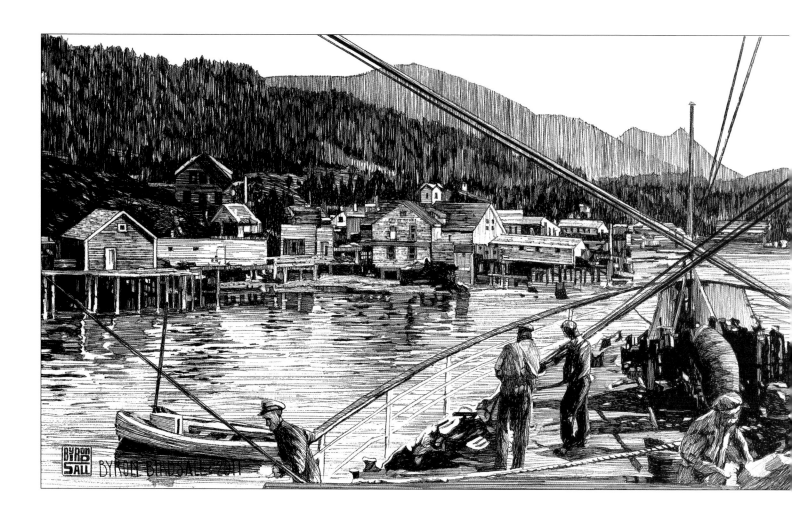

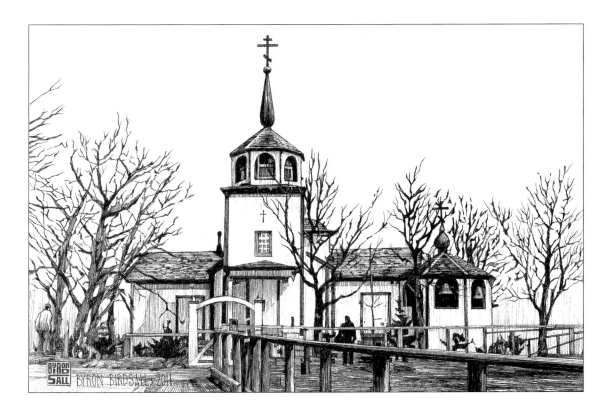

BYRON BIRDSALL · 2011

Seldovia—c. 1935: After the United States purchased Alaska from Russia, the importance of the Port of Seldovia grew as a fish-processing center. Much of the waterfront was destroyed in the 1964 earthquake.

Holy Resurrection Russian Orthodox Church, Kodiak—c. 1920: A legacy of Russian influence in Alaska, this church, originally established in 1794, was elevated to cathedral status in 2001.

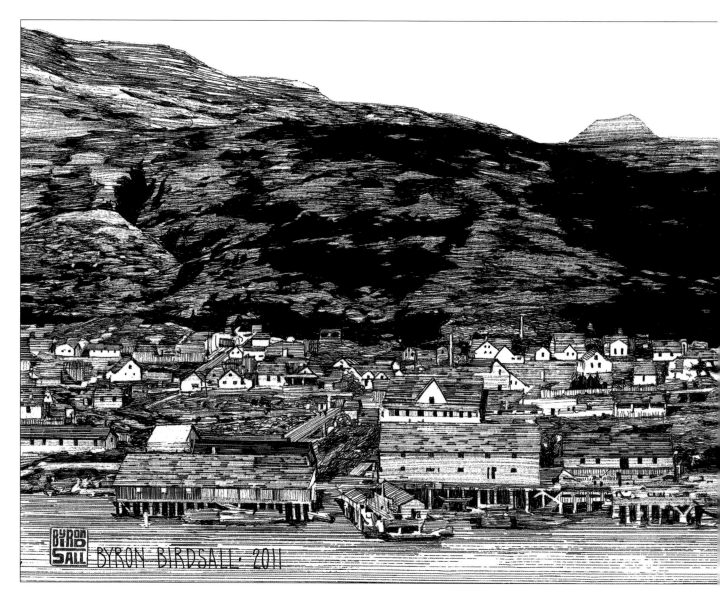

BYRON BIRDSALL · 2011

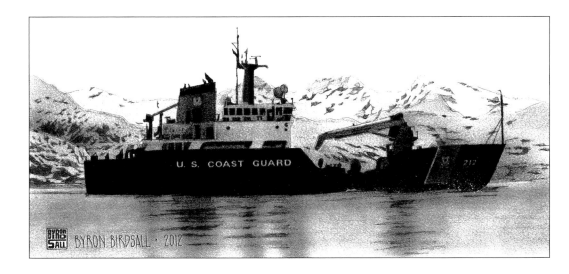

BYRON BIRDSALL · 2012

○ **Kodiak Waterfront—c. 1931:** Taking its name from the Alutiiq word for island, Kodiak features some of the oldest buildings in Alaska and has emerged as a commercial fishing hub.

○ **USCGC *Hickory 1*:** Nicknamed the "Kenai Keeper," the *Hickory* operates primarily as a buoy tender but can serve a multitude of purposes including maritime law enforcement.

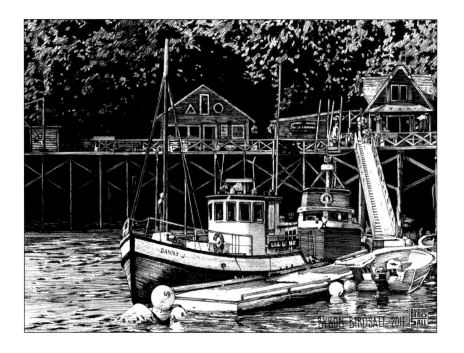

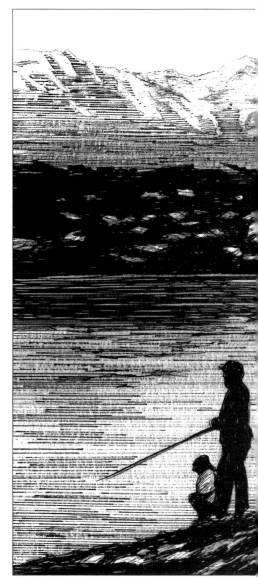

○ *Danny J* **in Halibut Cove:**
Crossing Kachemak Bay from Homer, the *Danny J* ferries tourists and locals alike to the art galleries and Saltry Restaurant in Halibut Cove.

○ Spit Fishing: Whether fishing in the hatchery-fed Nick Dudiak Fishing Lagoon or along the spit beaches, Homer offers tourists and locals a variety of fishing options.

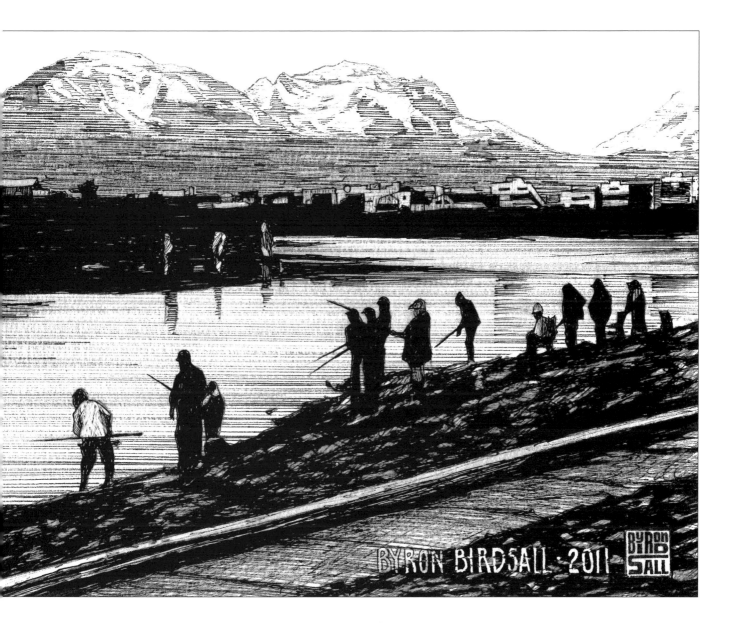

BYRON BIRDSALL · 2011

Beautiful Downtown Cordova— c. 1939: Named by the earliest Spanish explorers of Alaska, Cordova grew to supply the Kennecott copper mines and was once renowned for its razor clam industry.

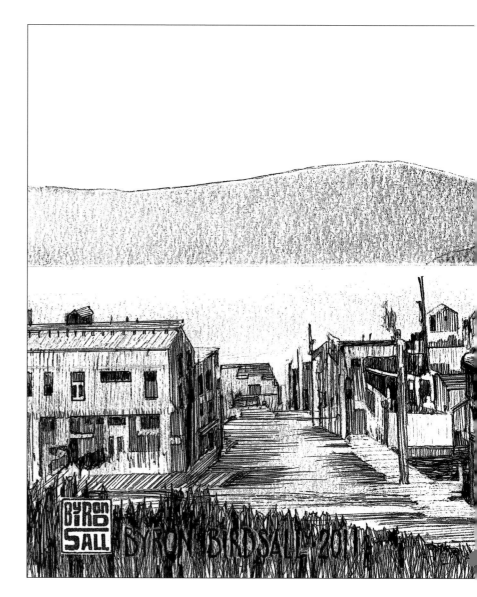

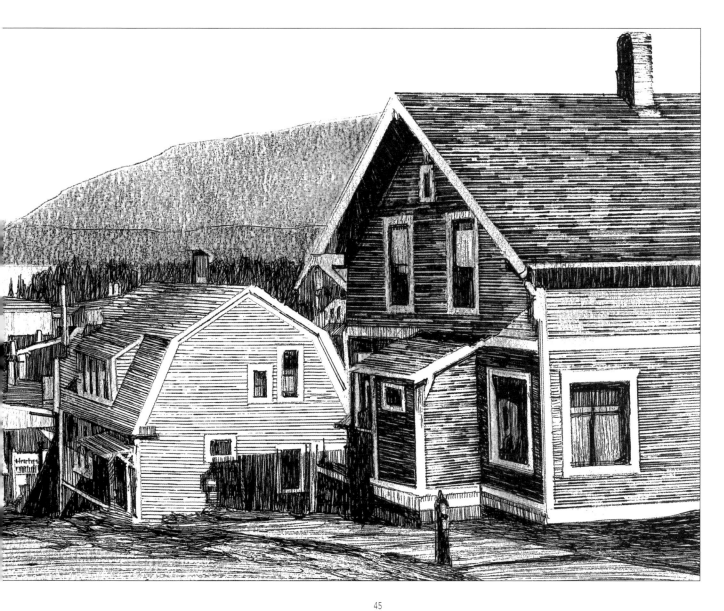

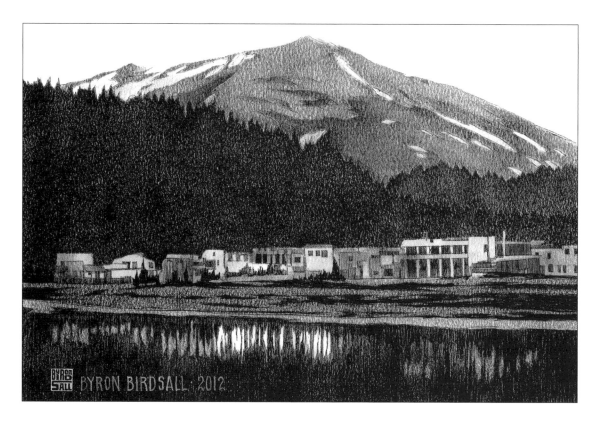

BYRON BIRDSALL · 2012

○ **Mount Marathon as seen from Seward by midnight—21 June 1917:** What started as a barroom bet to see whether a person could run up and down the mountain in an hour has become an annual Fourth of July tradition. The current record is 42:55.

○ **The Governor's Mansion, Juneau—c. 1939:** Painted a bold white in 1936, the Governor's Mansion has housed territorial and state governors alike. The six-bedroom, eight-fireplace home is an impressive 14,400 square feet.

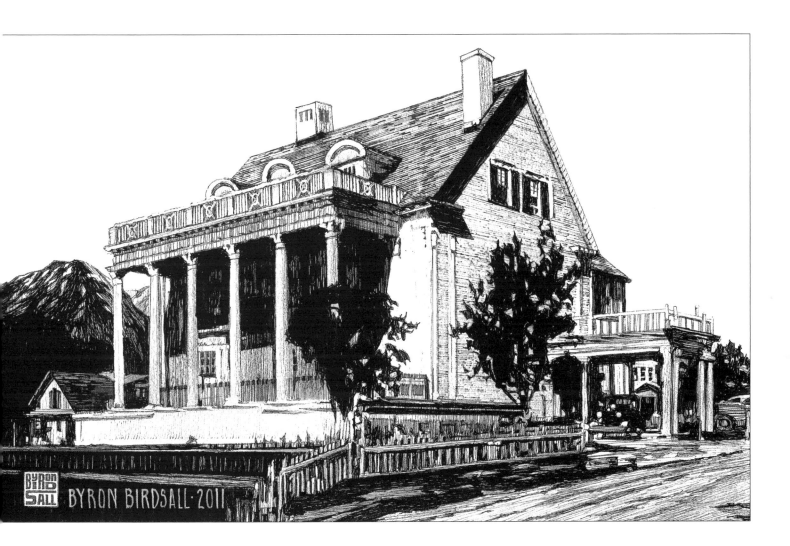

BYRON BIRDSALL · 2011

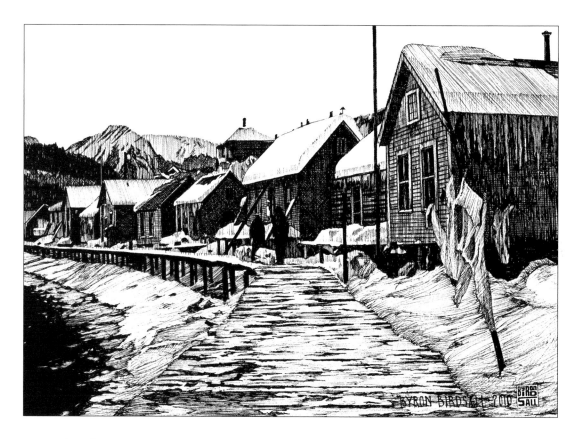

○ **Auke village, Juneau—c. 1920:** The Tlingit Auke, which means "Small Lake People," settled not far from Juneau. The site of their former village now serves as a US Forest Service recreation area.

○ **Beautiful Downtown Skagway—1930:** As one of the main entryways to the goldfields, Skagway blossomed from modest homestead to a city that hosts over 900,000 tourists traveling by cruise ships.

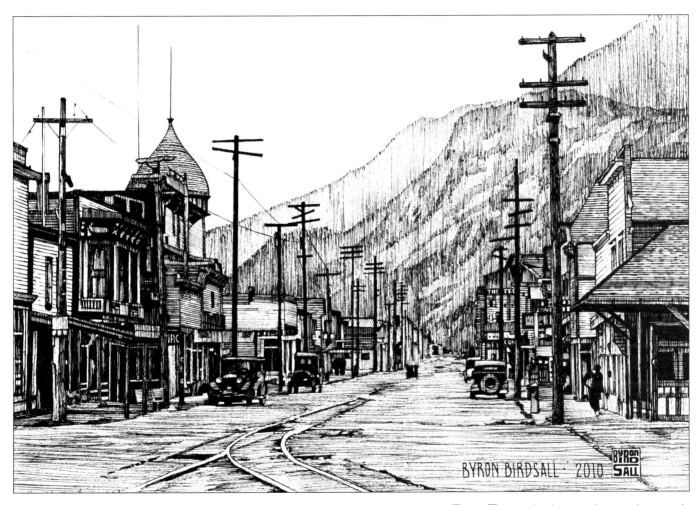

Lots of history here, all the more so because my daughter Courtenay lives here with her husband, Trevor. Trevor makes beer at a brewery that opened during the Gold Rush, and Courtenay is an artist, selling her masterpieces to throngs of tourists who invade Skagway during the summer. —B. B.

White Pass Railroad—1898: The primary passage to the Klondike goldfields, the White Pass Trail grew to accommodate a railroad. It continues today as a heritage railway.

Ascending Chilkoot Pass—1898: Determined to stake their claims in the goldfields beyond, thousands of prospectors crested the 3,501-foot-tall pass.

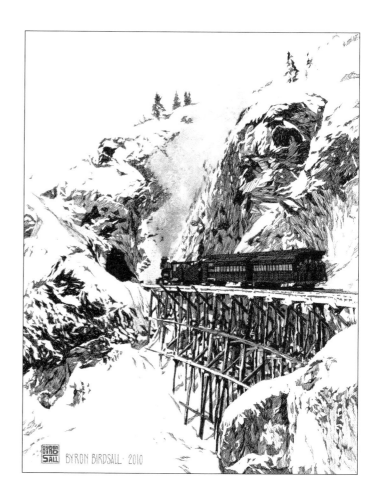

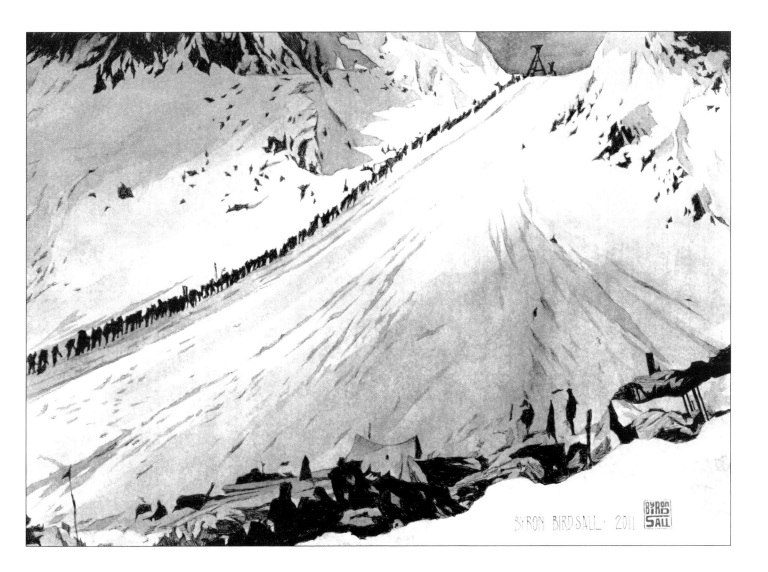

BYRON BIRDSALL · 2011

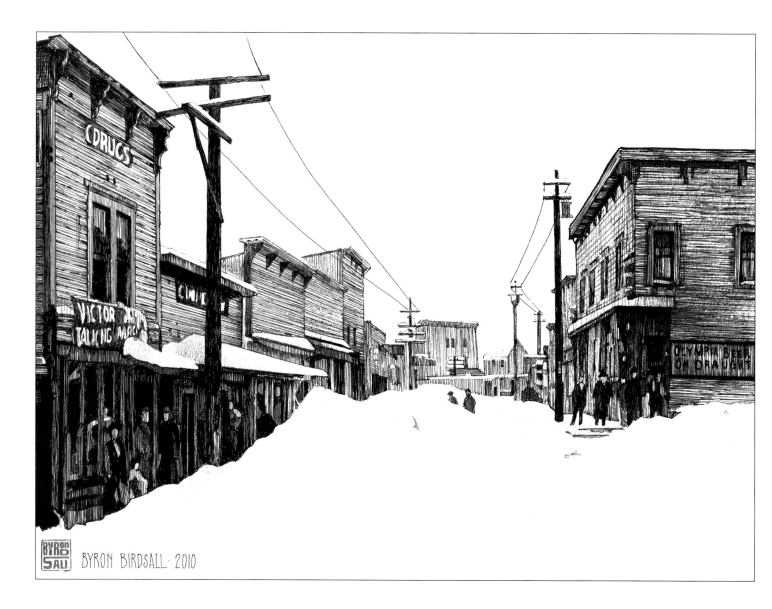

BYRON BIRDSALL · 2010

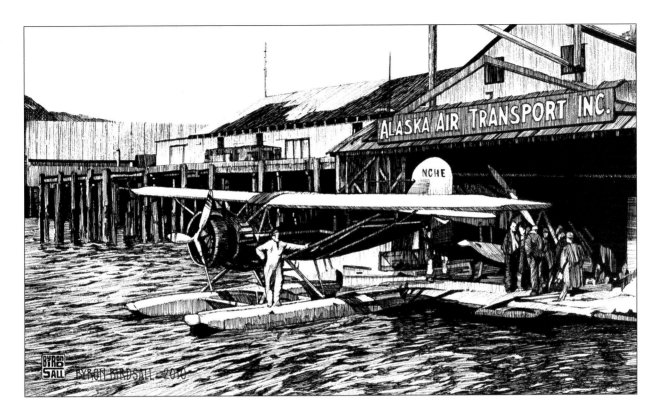

○ **Beautiful Downtown Douglas—c. 1930:** Before completion of the Douglas Bridge, Douglas and neighboring Juneau were connected only by ferry. Together, they're unified as the City and Borough of Juneau.

○ **Alaska Air Transport, Inc., Juneau— c. 1930:** With almost any body of water now a runway, floatplanes allowed early entrepreneurs and pioneers to settle areas previously inaccessible. Floatplanes remain an integral part of Alaskan life.

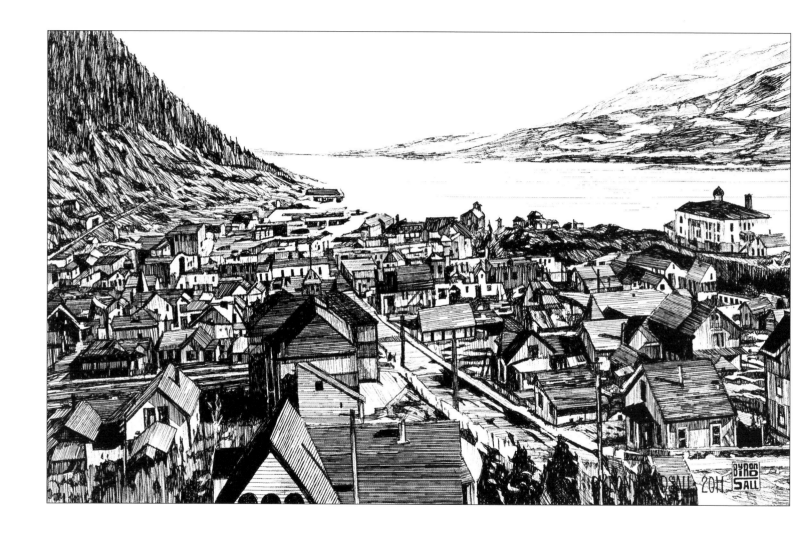

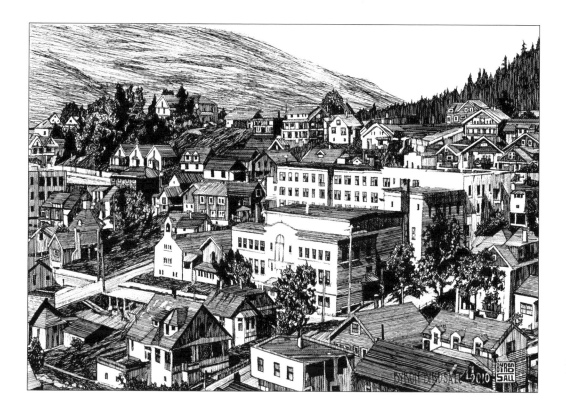

○ **Juneau—1909:** After the territorial government moved from Sitka, Juneau quickly became the most populated city in Alaska and would remain so until 1950.

○ **Beautiful Downtown Juneau—c. 1943:** Nestled between mountains over 3,500 feet high and the Gastineau Channel beyond, Juneau soon became a popular destination for tourists from land and sea.

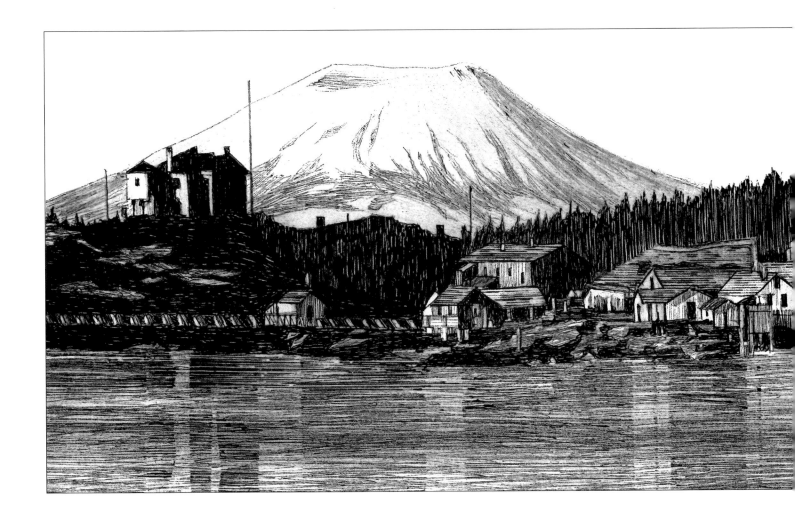

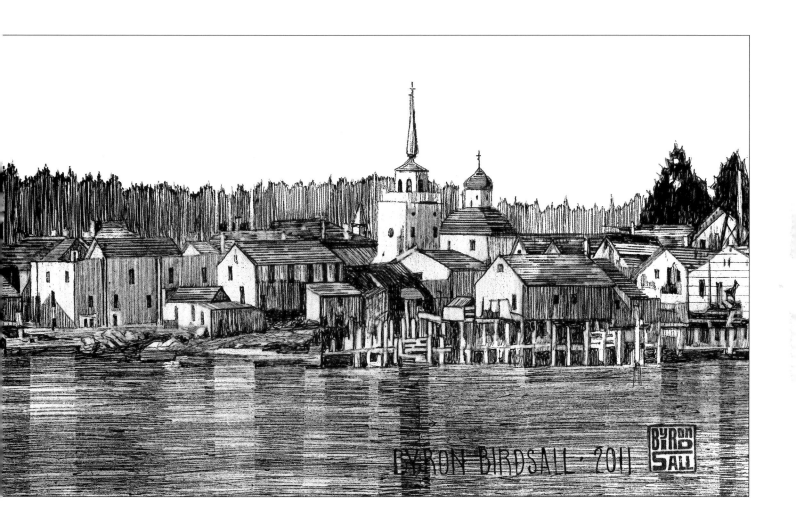

BYRON BIRDSALL · 2011

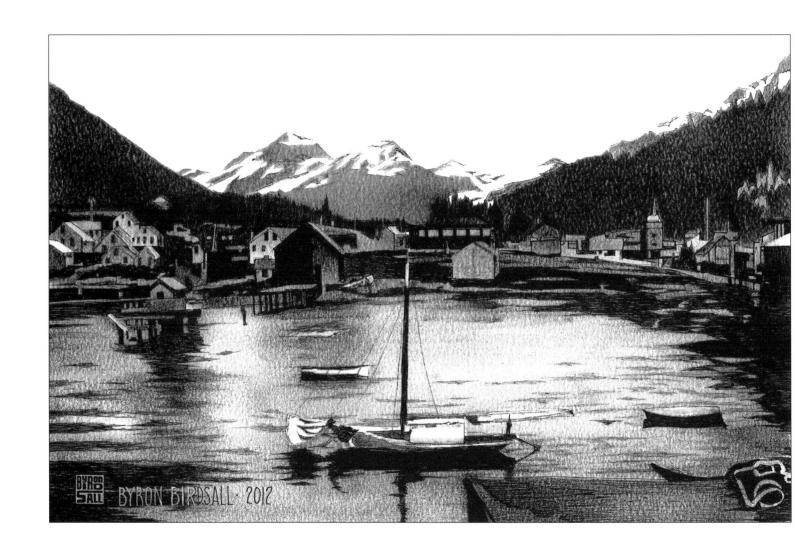

BYRON BIRDSALL · 2012

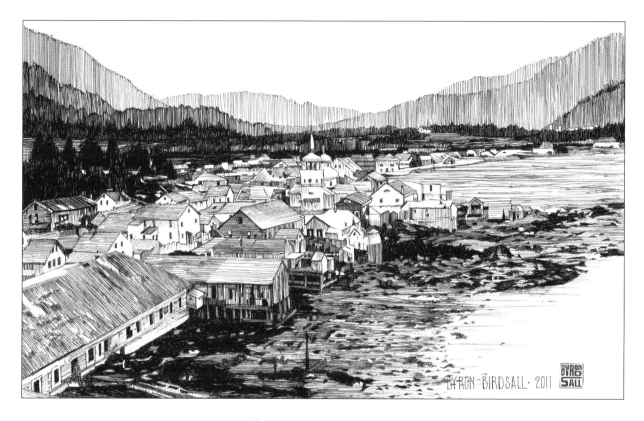

BYRON-BIRDSALL · 2011

○○ **Mt. Edgecombe and environs —1912:** A dormant volcano, Mt. Edgecumbe is about ten miles west of Sitka. As an April Fools' joke, a local prankster set tires aflame in the crater to create the illusion that the volcano was active.

○ **Sitka and the Three Sisters— c. 1920:** Home to many Alaskan firsts, like Sitka Lutheran Church, the first Protestant church on the West Coast, Sitka has steadily grown since its original founding in 1799.

○ **Beautiful Downtown Sitka— 1889:** The capital of Russian America, New Archangel would become Sitka and the site for the signing of the Alaska purchase, officially transferring the territory to the United States.

○ St. Michael's Cathedral, Sitka—1889:
Built in the mid-1840s, the cathedral was heavily damaged by a fire in 1966 but was rebuilt with copper-green domes.

○○ Baranov Castle, Sitka—1889: Built by Alexander Baranov, the castle overlooked the city and ocean alike. It was the site of several battles between the Tlingit and Russians.

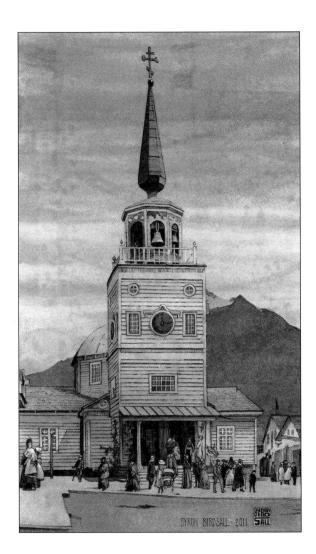

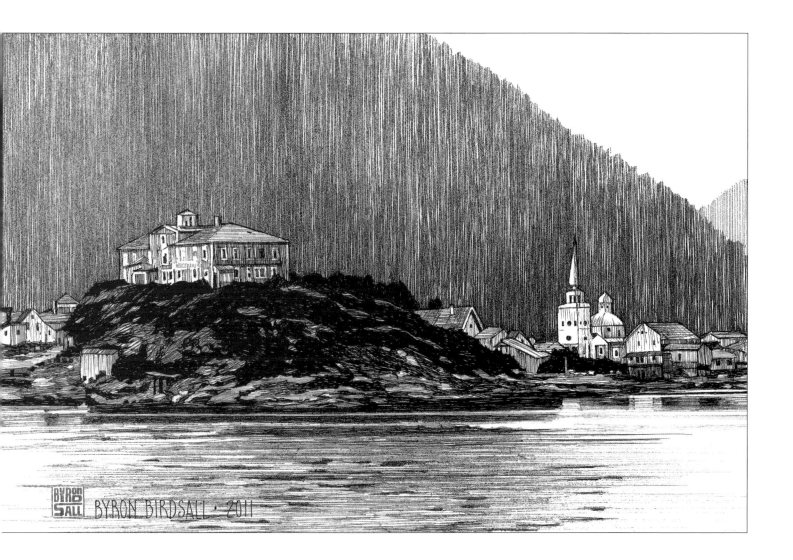

BYRON BIRDSALL · 2011

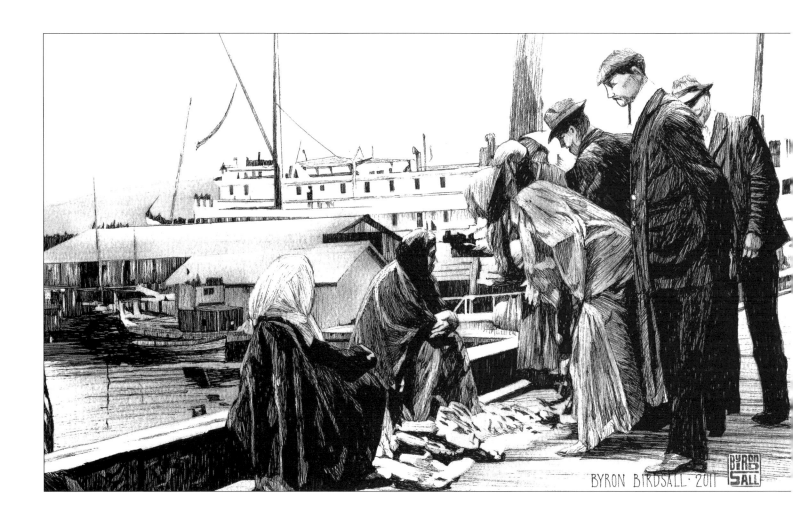

BYRON BIRDSALL · 2011

Shopping along the Petersburg Waterfront—c. 1914: Petersburg was founded by Norwegian fishermen in 1910. Like most island towns in Alaska, virtually all supplies came by cargo vessel or from the local fishing fleet.

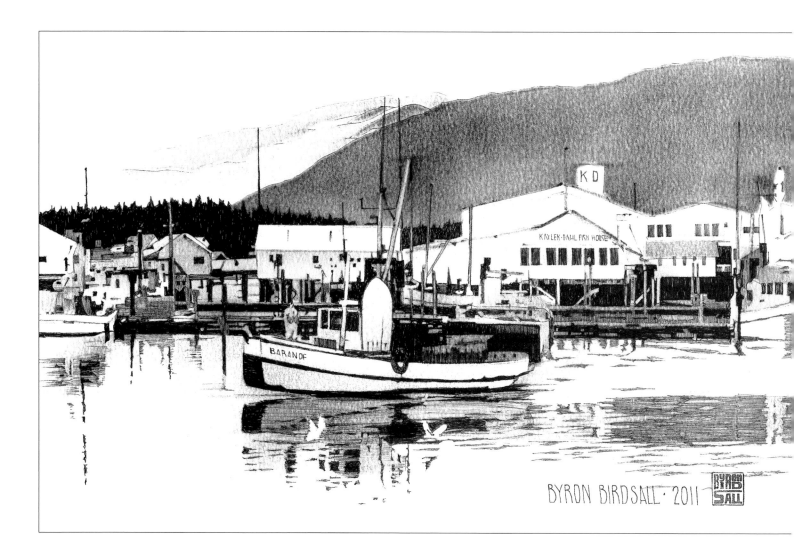

BYRON BIRDSALL · 2011

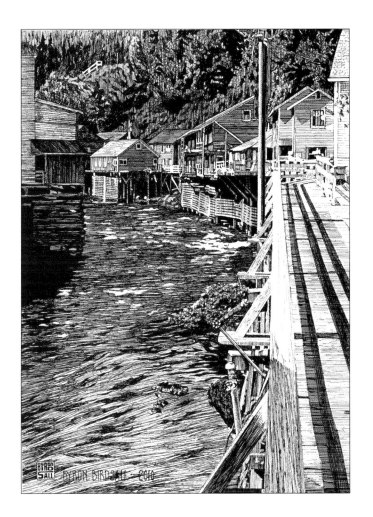

Almost an Alaskan cliché, but still one of the most charming "streets" in Alaska. There were some places here that I wouldn't want to have been caught going into. —B. B.

○○ **Petersburg waterfront:** Beginning as the homestead of Peter Buschmann, Petersburg would prosper after Buschmann's completion of a cannery and dock, which survive today.

○ **Creek Street, Ketchikan:** The red light district brothels remained active until 1954. The creek-side boardwalk now houses museums and shops and some of the best salmon-viewing areas in town.

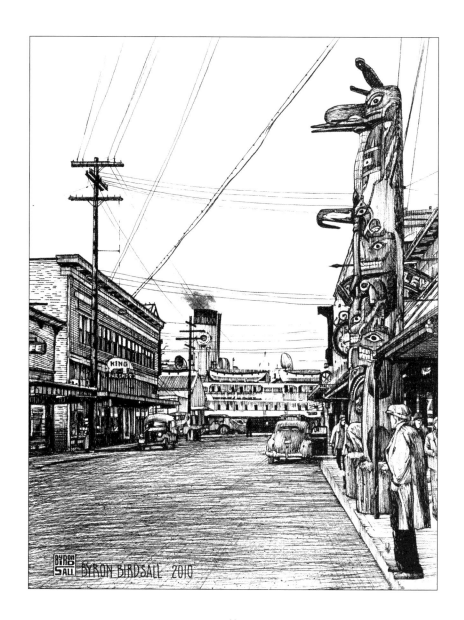

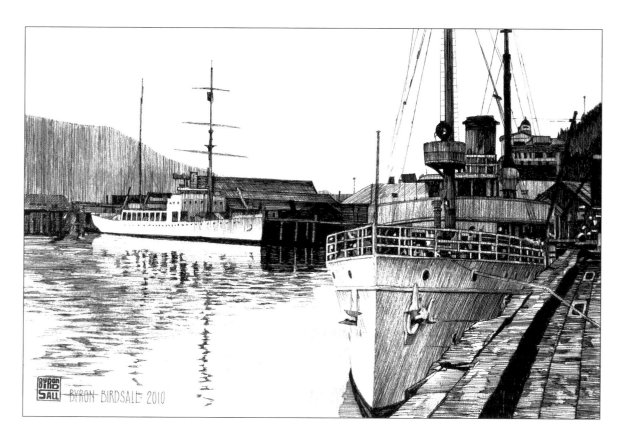

BYRON BIRDSALL 2010

Ⓞ Beautiful Downtown Ketchikan—c. 1935:
Celebrating its Native heritage, Ketchikan is
home to the largest collection of standing
totem poles in the world.

**Ⓞ Cruisers *Northland* and *Unalga*, Juneau—
c. 1925:** Two of the earliest Coast Guard vessels
in Alaska, the *Northland* and *Unalga*, patrolled
the Bering Sea. Both served in World War II, with
the *Northland* sent to Greenland and the *Unalga*
sent to Puerto Rico.

**Beautiful Downtown Yakutat—
c. 1920:** Meaning "the place where canoes rest" in Tlingit, Yakutat's development began with the Russian colony of New Russia in 1795.

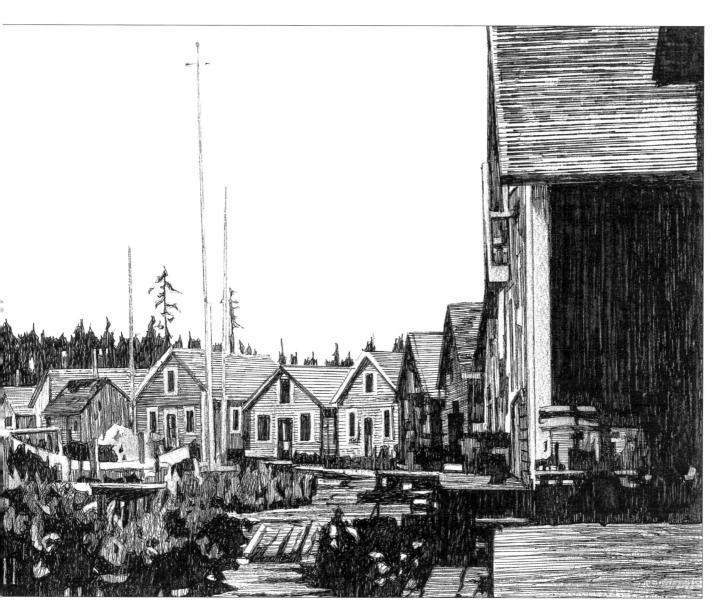

Alaska Highway—c. 1943:
World War II spurred the construction of the 1,387-mile highway to the outposts in Alaska after several of the territory's islands were invaded by the Japanese.

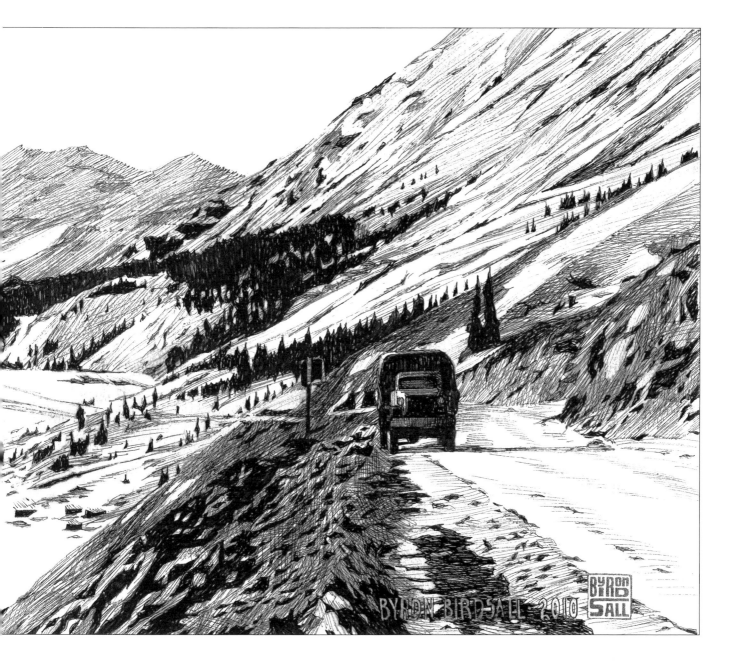

BYRON BIRDSALL 2010

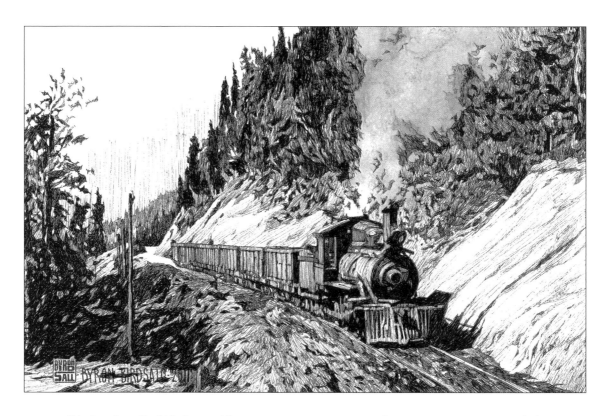

○ **Work train, mile 113, Copper River Railway—c. 1930:** Though shutdown in 1938, the railway passed over a hundred creeks, valleys, and canyons to haul the rich Kennecott copper ore to Cordova.

○ **Kennecott Copper Mine—1953:** A total of five mines made up the Kennecott Mine, reaching into one of the richest pockets of copper in the world. The ore was more than 70 percent pure copper.

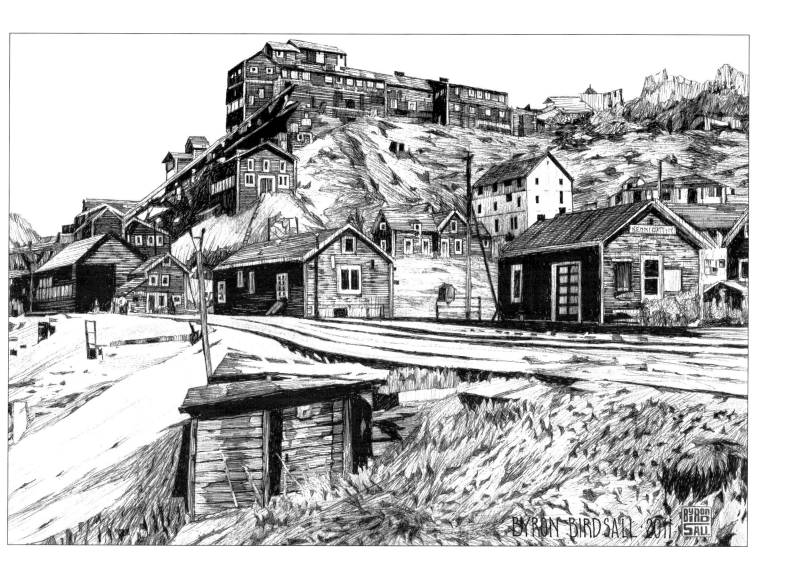

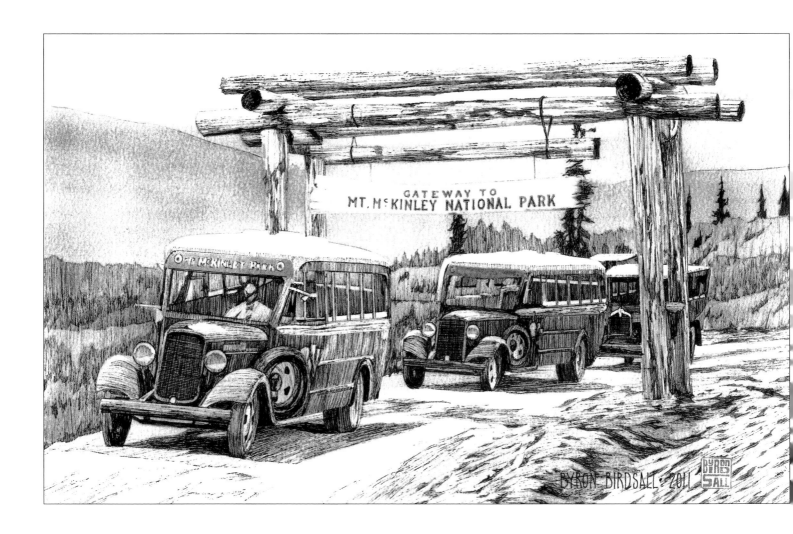

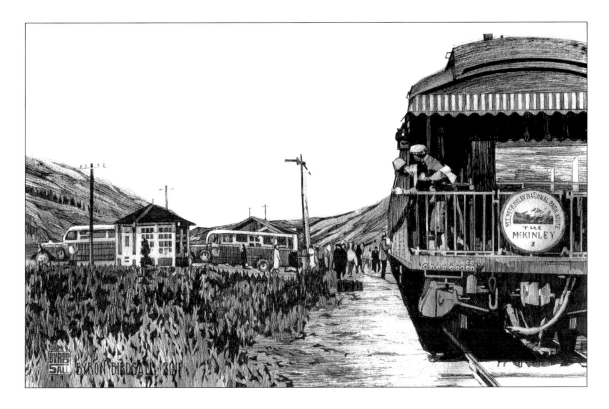

○ **Gateway to Mt. McKinley National Park— c. 1940:** Now called Denali National Park, this protected area stretches across more than six million acres. Mt. McKinley itself is so tall, at 20,237 feet, that it can be seen from Anchorage, over 133 miles away.

○ **McKinley Park Station—c. 1935:** Located midway between Fairbanks and Anchorage, McKinley Park Station has long been a dropping-off point for tourists and locals alike.

Rest Stop, Mt. McKinley National Park—c. 1940: A ninety-one-mile-long road winds through the park. After the first fifteen miles, access to the park is limited to buses, so as to avoid disturbing the wildlife.

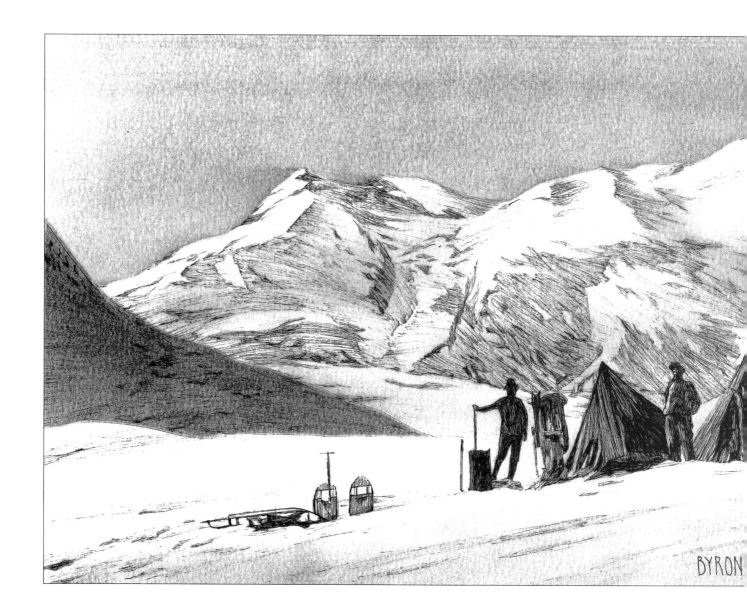

Campsite near Muldrow Glacier where Theodore Koven was found—1932: Scientist Theodore Koven died while studying high-altitude cosmic rays on the Muldrow Glacier, east of Mt. McKinley in Denali National Park.

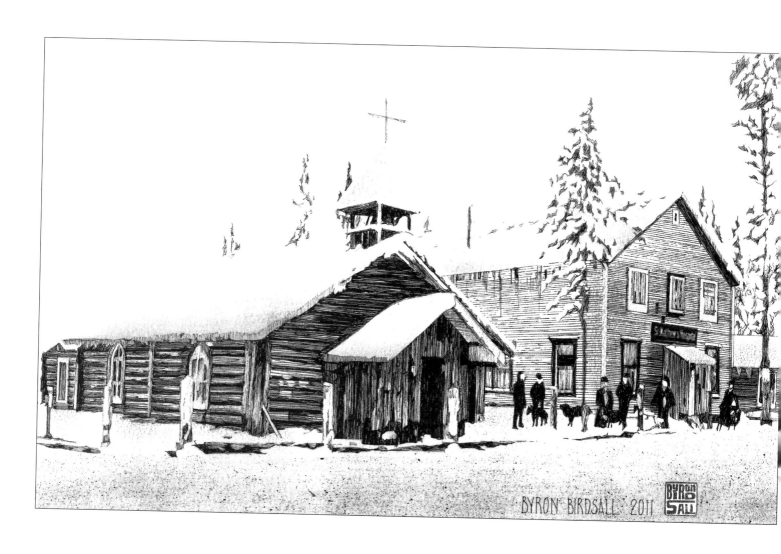

BYRON BIRDSALL 2011

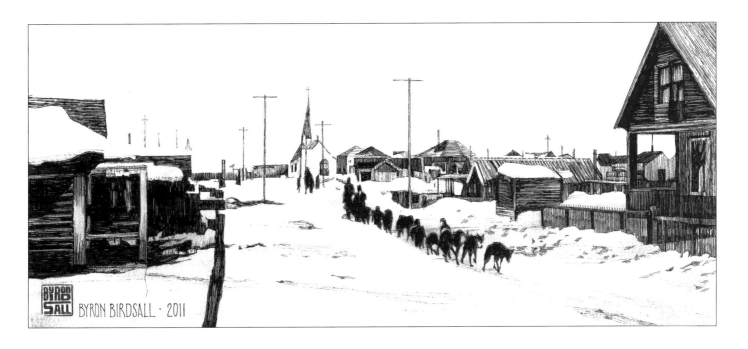

BYRON BIRDSALL · 2011

○ **St. Matthew's Episcopal Church and Hospital, Fairbanks—1910:** After building the first hospital in Fairbanks, Bishop Peter Trimble Rowe built the adjacent log church. The hospital is believed to be the first framed building in Fairbanks.

○ **Mail leaving Fairbanks—1917:** Though Fairbanks had lost its gold rush population, there were many that stayed, as the Tanana Valley was suitable for agricultural development.

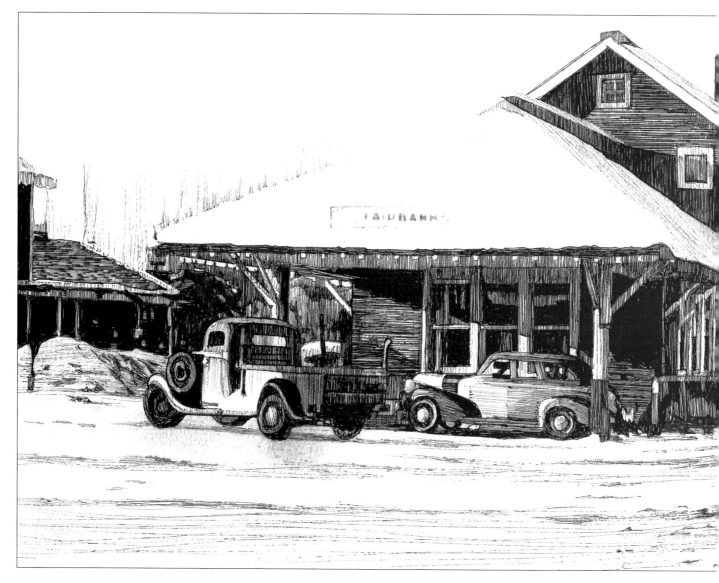

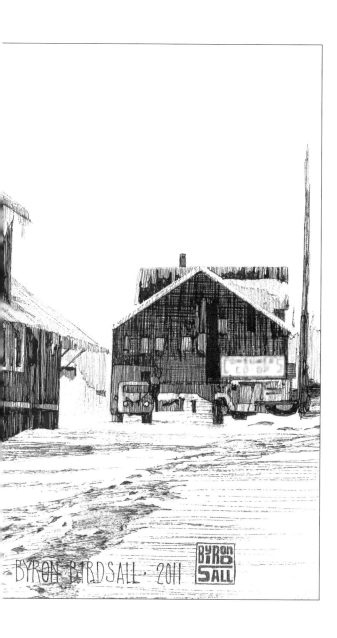

Railroad Depot, Fairbanks— c. 1940: Now the second-largest depot on the line, the northern line was originally built to connect the goldfields to the steamboats on the nearby Chena River.

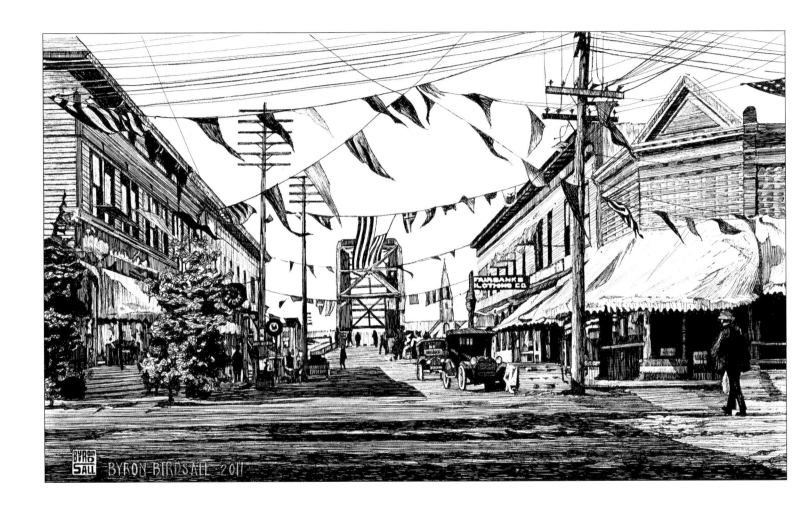

BYRON BIRDSALL -2011

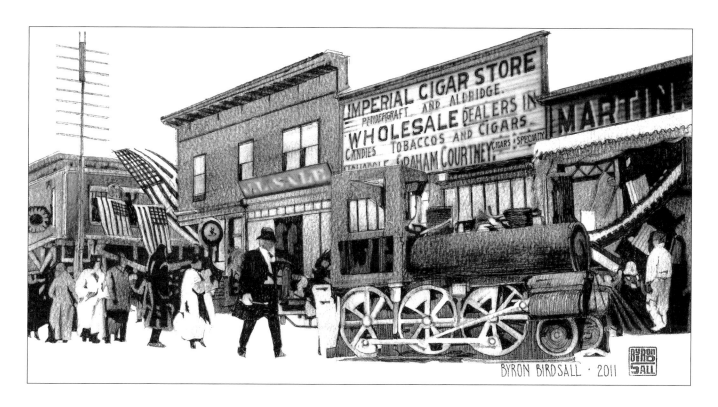

BYRON BIRDSALL · 2011

⟳ Fairbanks—July 4, 1917: Named after Charles W. Fairbanks, the twenty-sixth vice president of the United States, Fairbanks sits just 120 miles south of the Arctic Circle but temperatures there can reach over 90°F in the summer.

⟳ Let's Have a Parade! Fairbanks—23 February 1914: Shriners parade through Fairbanks after the US Congress passed a bill to purchase lines and connect the railroad to Seward.

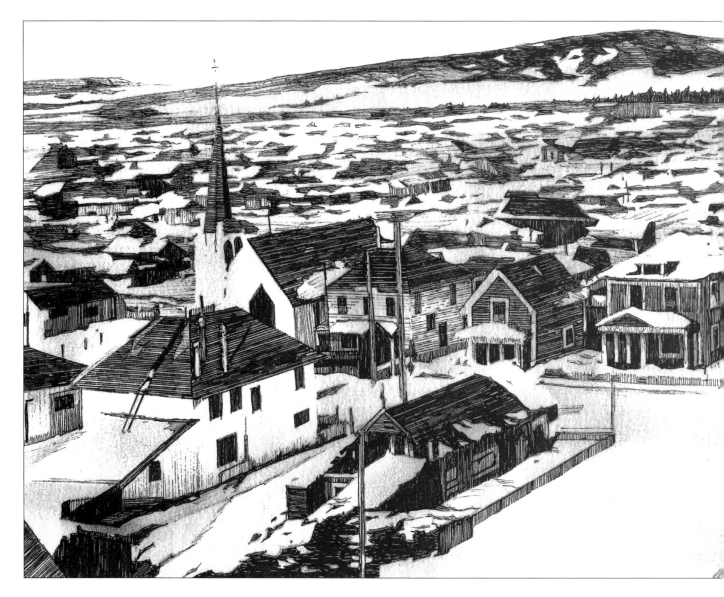

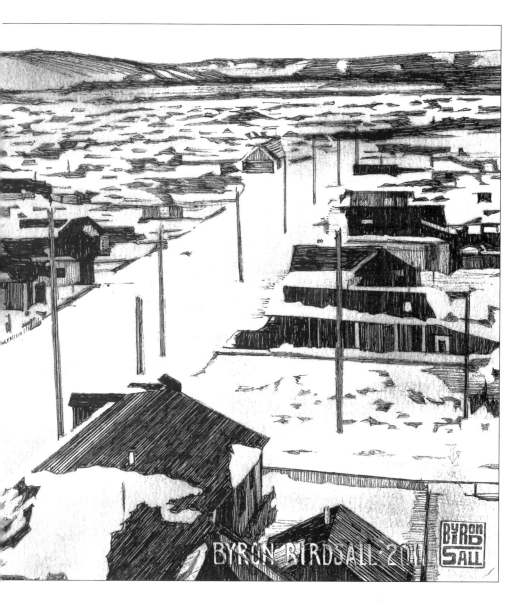

Beautiful Downtown Fairbanks— 1916: Adapting to the decline in gold mining, Fairbanks invested in itself with the Alaska Agricultural College and School of Mines.

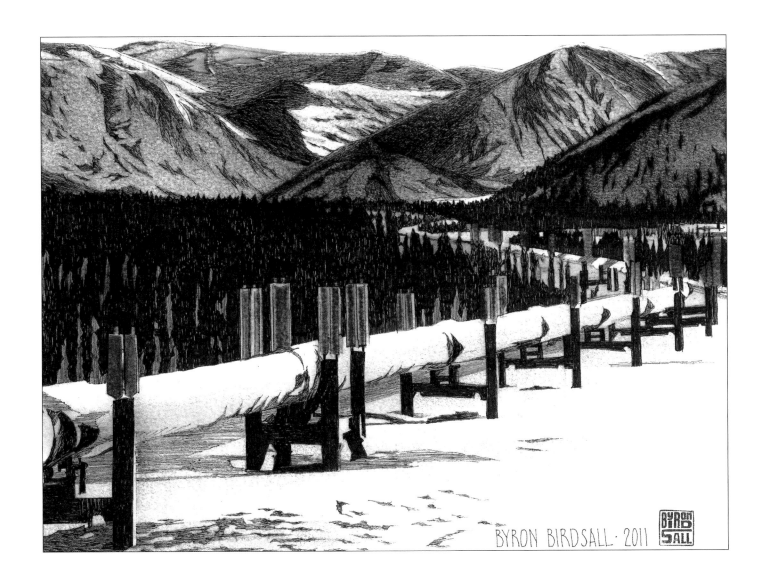

BYRON BIRDSALL · 2011

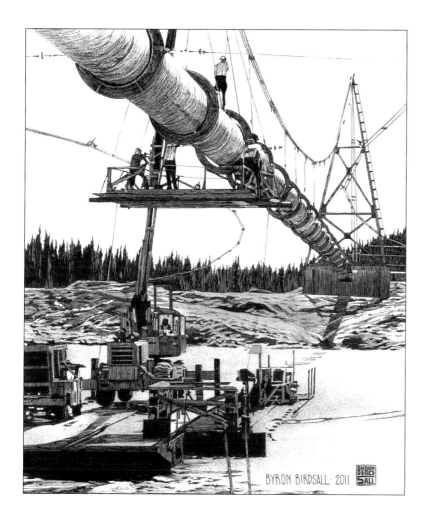

BYRON BIRDSALL: 2011

⊙⊙ Near the south fork of the Koyukuk River—1975: An engineering marvel, and at the time the most expensive private construction in world history, the Trans-Alaska Pipeline has transported almost 16 billion barrels of oil since its construction.

⊙ Tazlina pipeline bridge—1977: Construction of an Arctic pipeline created unique challenges for engineers. Over its length, the pipeline would experience drastically different temperatures and terrain.

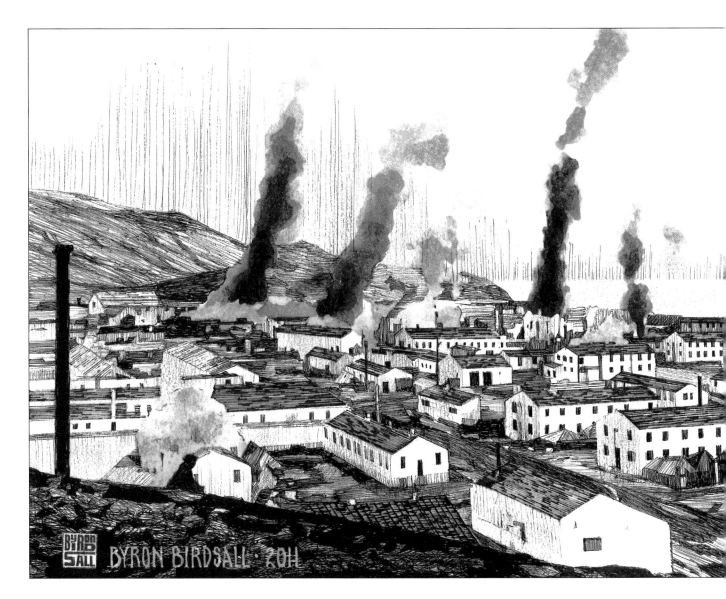

BYRON BIRDSALL · 2011

Alaska under attack by the Japanese during World War II. Largely forgotten now, but very real at the time. —B. B

Attack on Dutch Harbor—3 June 1942: In one of the least known campaigns of World War II, Dutch Harbor in the Aleutian Islands suffered two days of bombing and strafing runs from Japanese fighters and bombers.

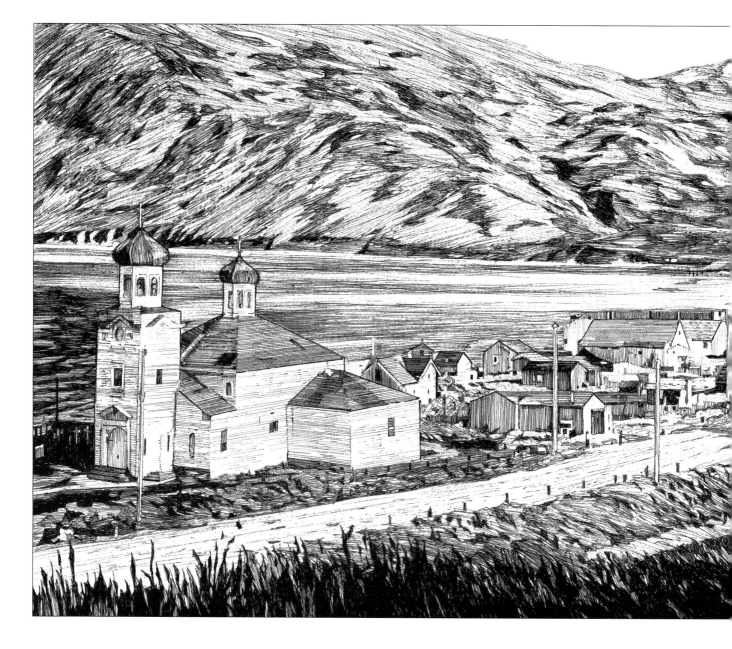

Beautiful Downtown Unalaska—c. 1949:
Located among the Fox Islands, Unalaska was already well on its way to becoming the major fishing port it is today, producing the largest catch by volume in the entire United States.

The USRC *Bear*—1898: Starting out as a sealing ship, the *Bear* would go on to serve in the Revenue Cutter Service and Coast Guard, and also appeared in the movie adaptation of Jack London's *The Sea-Wolf.*

The USCGC *Bear* as seen from the SS *Victoria*, Bering Sea—June 1918: As part of the newly formed Coast Guard, the *Bear* patrolled thousands of miles of Alaskan coastline for poachers and smugglers, and is seen here with the Alaska Steamship Company's SS *Victoria.*

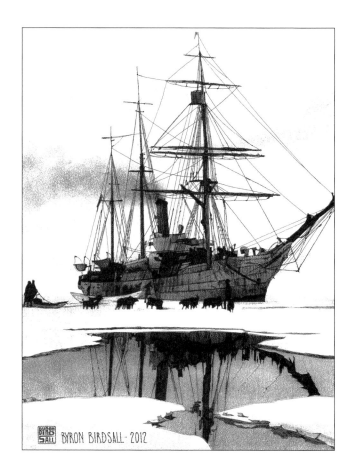

BYRON BIRDSALL · 2012

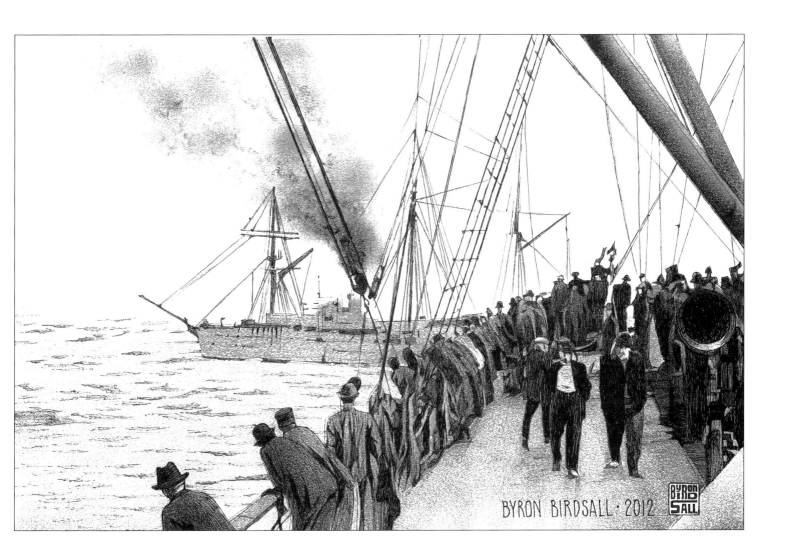

BYRON BIRDSALL · 2012

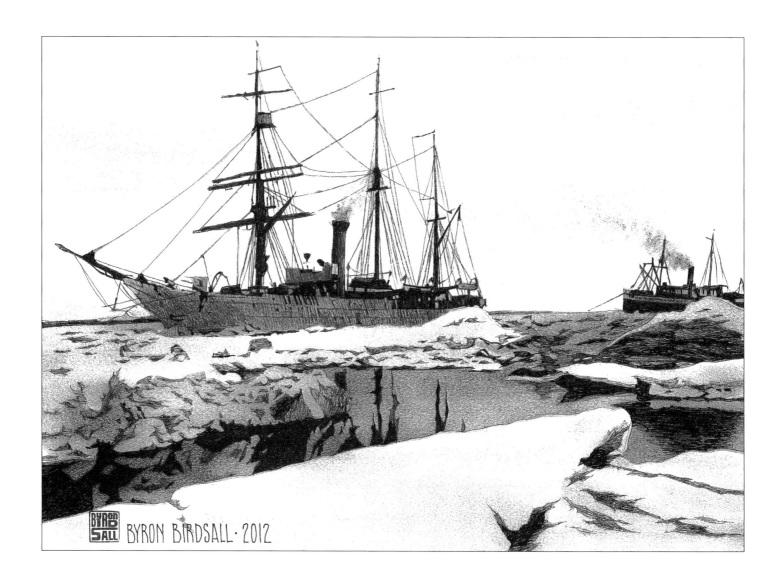

BYRON BIRDSALL · 2012

The USRC *Bear* and SS *Corwin*, Roadstead, Nome: Past and present cutters meet. The SS *Corwin* was one of the first Revenue Cutters in Alaskan waters before being refit as a merchant vessel in 1900.

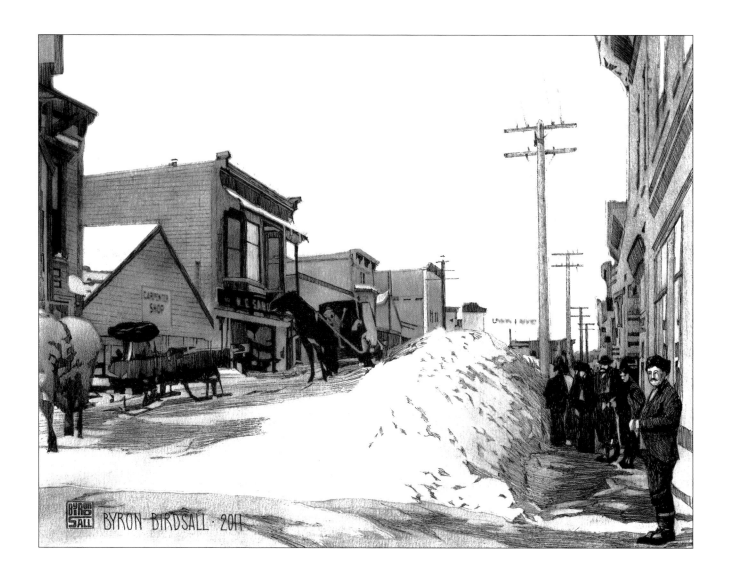

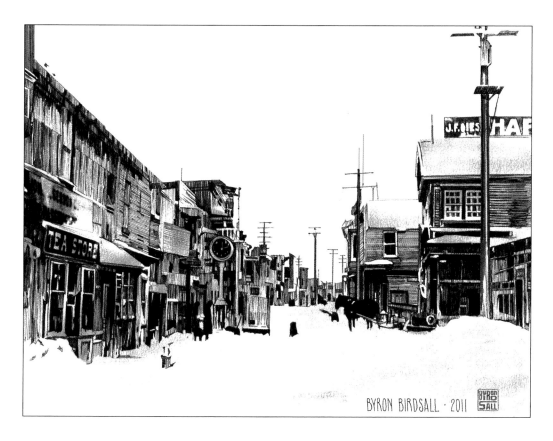

BYRON BIRDSALL · 2011

○ **Front Street, Nome—2 April 1907:** The famous Western sheriff Wyatt Earp traveled to Nome and opened one of the largest saloons in town, the Dexter. He told his brothers he was "mining the miners."

○ **Front Street, Nome—1907:** From steamship tickets to cigars, Front Street offered services to the many thousands of prospectors who had come to Nome to mine or dredge their fortunes among the gold-laden beaches.

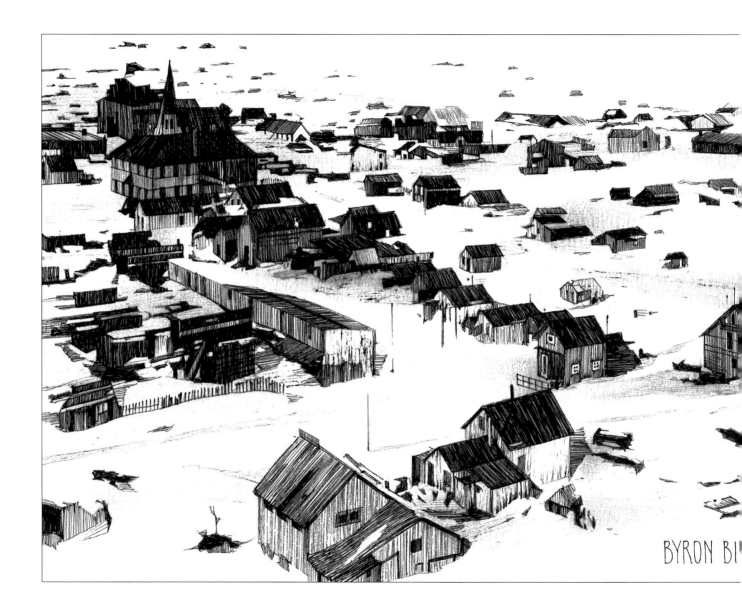

BYRON BI

Beautiful Downtown Nome—1907: As with many gold boomtowns in Alaska, Nome was briefly the most populated city, with more than 10,000 people living there a decade before Anchorage was founded.

. . . for Hugh and Lanie Fleischer, who have given so much to Alaska.

Library of Congress Control Number: 2015931980

Design by Vicki Knapton

Published by Alaska Northwest Books®
An imprint of

GRAPHIC ARTS
BOOKS®

P.O. Box 56118
Portland, Oregon 97238-6118
503-254-5591
www.graphicartsbooks.com

Printed in China

ABOUT THE ARTIST

A self-taught and internationally recognized artist, Byron Birdsall is renowned for the variety and drama of his Alaskan landscapes, his unique ability to capture light, and his nostalgic renderings of historic scenes—the focus of this book.

Birdsall's paintings are included in the collections of a number of museums and public institutions, hang in corporate boardrooms and atriums, and are owned by royalty, presidents, new fans, and loyal friends. He designed a US postage stamp in 1992 that commemorated the building of the Alcan Highway, and as an avid stamp collector, he regards this as a personal high point.

In 2005 Birdsall had the honor of appointment as guest artist to the American Academy in Rome where he painted for three months. His most recent publication is *People of the Saltchuk*, a volume of 150 paintings for a maritime transport company with holdings around the world. This has taken the inveterate traveler to South America, Korea, New England, and Sakhalin Island north of Japan. In addition he has traveled to Russia, the better to study icons, as he has a great interest in iconography, then to Israel to do paintings for a show in aid of Temple Beth Shalom in Anchorage. He has been generous with his work, contributing to many worthy causes and organizations including the Alaska Folk Festival and UNESCO.

Birdsall and his wife now divide their time between their homes on Whidbey Island in Washington State and Anchorage, Alaska.